サードウェーブ・
デザイン

Third Wave Design
Cool Coffee-inspired Designs for
an Easygoing, Natural Lifestyle

3rd wave DESIGN

Third Wave Design
Cool Coffee-inspired Designs for an Easygoing, Natural Lifestyle

©2016 PIE International
All rights reserved. No part of this publication may be reproduced,
stored in a retrieval system, or transmitted in any form or by any
means, graphic, electronic or mechanical, including photocopying
and recording, or otherwise, without prior permission in writing
from the publisher.

PIE International Inc.
2-32-4 Minami-Otsuka, Toshima-ku, Tokyo 170-0005 JAPAN
sales@pie.co.jp

ISBN978-4-7562-4805-3 Printed in Japan

CONTENTS
もくじ

FOREWORD はじめに　　004

STYLISH & COOL　　007
スタイリッシュ & クール

POP & COLORFUL　　055
ポップ & カラフル

RELAXED & NATURAL　　089
リラックス & ナチュラル

NOSTALGIC & NEW RETRO　　135
ノスタルジック & ニューレトロ

SHOP IMAGE　　173
ショップイメージ

LOGO　　210
ロゴ

INDEX インデックス　　217

FOREWORD

Design expressing an "easygoing, natural lifestyle" based on the culture of Portland, Oregon, where graphic techniques rooted in things handmade, DIY, and letterpress printing are the rage, has crossed the Pacific. Here it has evolved into a uniquely Japanese trend that combines techniques the likes of handwriting, chalkboard lettering, and the "flaws" of hand-printing with stylish fonts and illustrations.

Third Wave Design presents promotional works from Japan and abroad blending design at the peak of perfection and a contemporary take on good-old American visuals, or what we term of "new retro" design, grouped under the following six categories.

- **Stylish and cool**
- **Pop and colorful**
- **Relaxed and natural**
- **Nostalgic and new retro**
- **Shop image**
- **Logo**

We hope the collection will provide a wealth of inspiration resulting in the production of fresh designs.

In closing, we would like to take this opportunity to express our appreciation to all the people who provided us wonderful examples of their work and contributed to the production of this book.

The editors, PIE Books

はじめに

ハンドメイドやDIY、活版印刷が根づいていて、グラフィック的な手法も盛んなポートランド文化をベースに、手書き、チョーク文字、「かすれ」「にじみ」の手法、スタイリッシュな書体やイラストを使い、"心地よさ"を表現したデザインが、日本独自のトレンドとして進化しているように感じられます。

本書では今、旬なデザインと古きよきアメリカのビジュアルを現代風にアレンジしたニューレトロなデザインの国内外の広告作品を6つのコンテンツに分けてご紹介します。

- **スタイリッシュ & クール**
- **ポップ & カラフル**
- **リラックス & ナチュラル**
- **ノスタルジック & ニューレトロ**
- **ショップイメージ**
- **ロゴ**

本書が、フレッシュなデザインのヒントになれば幸いです。

最後になりましたが、作品をご提供いただきました出品者の方々、制作関係者の方々へ、この場を借りまして、心より御礼を申し上げます。

PIE BOOKS編集部

EDITORIAL NOTES
エディトリアルノート

CREDIT FORMAT
クレジットフォーマット

P.008-172

作品名　Name of work
クライアント［業種名］　Client［Type of Industry］
スタッフクレジット　Staff Credit

スタッフクレジットの略称は以下の通りに表記しております。

CD：クリエイティブ・ディレクター　Creative Director
AD：アート・ディレクター　Art Director
 D：デザイナー　Designer
CW：コピーライター　Copywriter
 P：フォトグラファー　Photographer
 I：イラストレーター　Illsutrator
Pr：プロデューサー　Producer
 A：広告代理店　Advertising Agency
DF：デザイン会社　Design Firm
SB：作品提供者（社）　Submittor

P.210-216

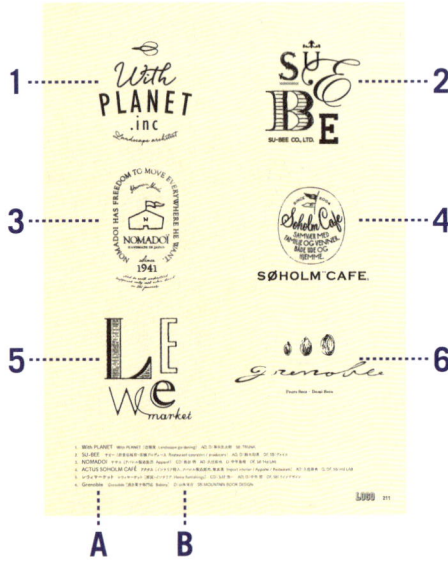

A　作品名・クライアント［業種名］
　　Name of work・Client［Type of Industry］
B　スタッフクレジット　Staff Credit

P.174-209

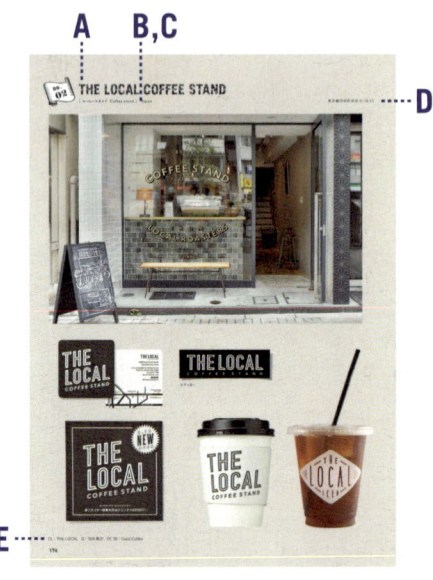

A　店名　Name of shop
B　業種　Type of Industry
C　国名　Country
D　住所（日本のお店のみ記載）
　　Address (for shops in Japan only)
E　スタッフクレジット　Staff Credit

・上記以外の制作者呼称は、省略せずに掲載しております。
　All other production titles are unabbreviated.
・本書に掲載されていますキャンペーン、プロモーションは既に終了しているものも
　ございますので、ご了承ください。
　Please be aware that sales campaigns and promotions may have already ended.
・作品提供者の意向により、データを一部記載していない場合があります。
　Some credit data has been omitted at the contributor's request.
・各企業名に付随する、株式会社、（株）、および有限会社、（有）などの表記は、
　省略させていただいております。
　The Kabushiki-gaisha (K.K./Inc.) and Yugen-gaisha (Ltd.) portions of
　all company names have been omitted.
・本書に掲載された企業名・商品名は、掲載各社の商標または登録商標です。
　Company and product names that appear in this book are trademarks
　and/or registered trademarks.

STYLISH & COOL

HAKUBA_VILLAGE

HAKUBA's GREEN SEASON
The sight of the mountains will take your breath away.

HAKUBA is a village located in the Kitaazumi District, Nagano Prefecture, Japan.
It is at the foot of the Northern Japan Alps, with mountain climbing visitors in summer,
and skiers visiting in winter.

GORYUDAKE
36° 39' 30" N, 137° 45' 10" E / 2814M
KARAMATSUDAKE
36° 41' 14" N, 137° 45' 17" E / 2696M
HAKUBAYARIGATAKE
36° 43' 53" N, 137° 45' 19" E / 2903M
SHAKUSHIDAKE
36° 44' 26" N, 137° 45' 33" E / 2812M
SHIROUMADAKE
36° 45' 31" N, 137° 45' 31" E / 2932M

Latitude / Longitude / Altitude Geospatial Information Authority of Japan

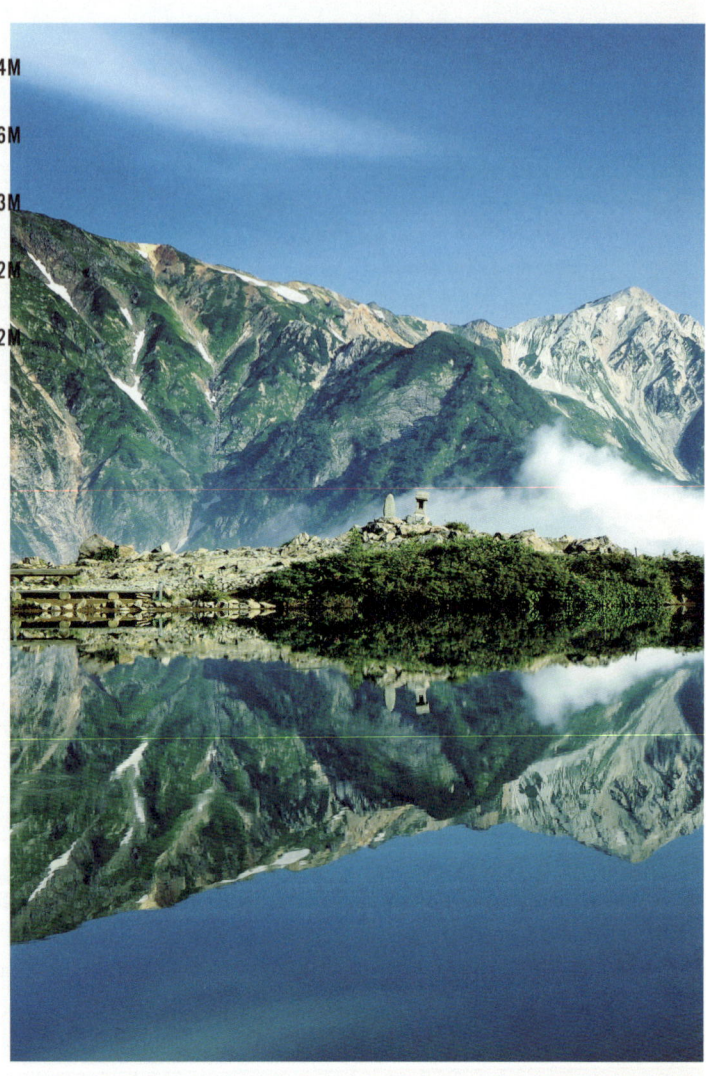

Happo-Ike (Happo Pond) / 2060m

DRAMATIC NATURE DAYS

GORYUDAKE
36° 39' 30" N, 137° 45' 10" E / 2814M
KARAMATSUDAKE
36° 41' 14" N, 137° 45' 17" E / 2696M
HAKUBAYARIGATAKE
36° 43' 53" N, 137° 45' 19" E / 2903M
SHAKUSHIDAKE

HAKUBA VILLAGE　キャンペーンポスター　白馬村観光局　［地方自治団体　Tourism commission］
AD, D：永田 傑　　P：山本尚明　　CW：村田綾子　　A：リアルホールディングス　　DF, SB：ナガタデザイン

GORYUDAKE
36° 39' 30" N, 137° 45' 10" E / 2814M
KARAMATSUDAKE
36° 41' 14" N, 137° 45' 17" E / 2696M
HAKUBAYARIGATAKE
36° 43' 53" N, 137° 45' 19" E / 2903M
SHAKUSHIDAKE
36° 44' 26" N, 137° 45' 33" E / 2812M
SHIROUMADAKE
36° 45' 31" N, 137° 45' 31" E / 2932M

HAKUBAVALLEY

Latitude / Longitude / Altitude : Geospatial Information Authority of Japan.

GORYUDAKE
36° 39' 30" N, 137° 45' 10" E / 2814M
KARAMATSUDAKE
36° 41' 14" N, 137° 45' 17" E / 2696M
HAKUBAYARIGATAKE
36° 43' 53" N, 137° 45' 19" E / 2903M
SHAKUSHIDAKE
36° 44' 26" N, 137° 45' 33" E / 2812M
SHIROUMADAKE
36° 45' 31" N, 137° 45' 31" E / 2932M

http://www.vill.hakuba.nagano.jp/

Happo-ike (Happo Pond) / 2060m

HAKUBA_VILLAGE

HAKUBA's GREEN SEASON
The sight of the mountains will take your breath away.

HAKUBA is a village located in the Kitaazumi District, Nagano Prefecture, Japan.
It is at the foot of the Northern Japan Alps, with mountain climbing visitors in summer,
and skiers visiting in winter.

STYLISH & COOL

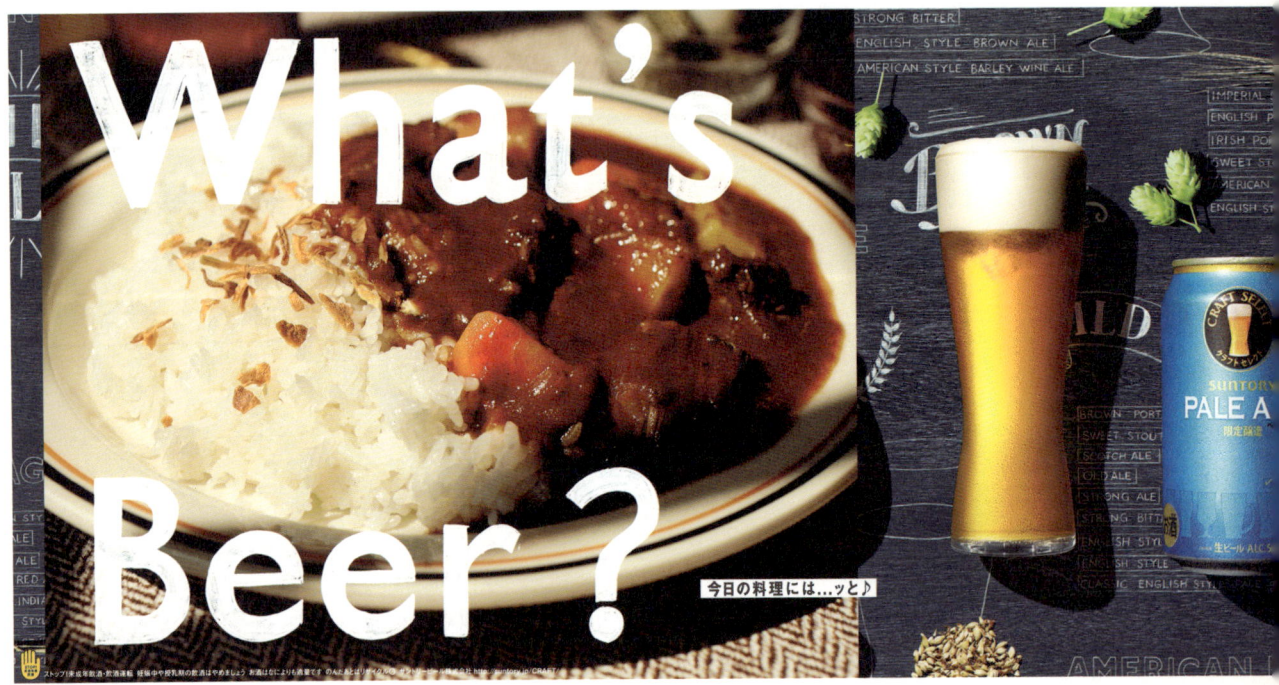

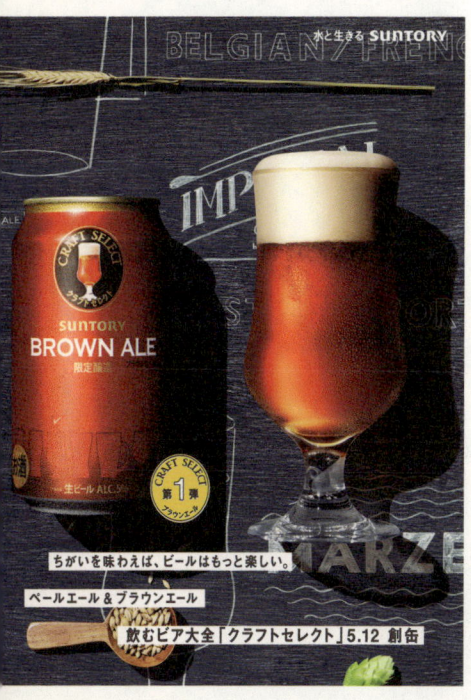

クラフトセレクト　ポスター
サントリービール ［国内・海外のビール事業　Domestic / import beers］
CD：高草木博純　AD：戸田宏一郎 / 上西祐理　D：渡邊 亮 / 藤本美菜子 / 菅原宏美
P：岩本 彩　I：徳永明子　CW：忽那治郎　プランナー：舩木展子　A：電通　DF, SB：J.C.SPARK

STYLISH & COOL

ポスター

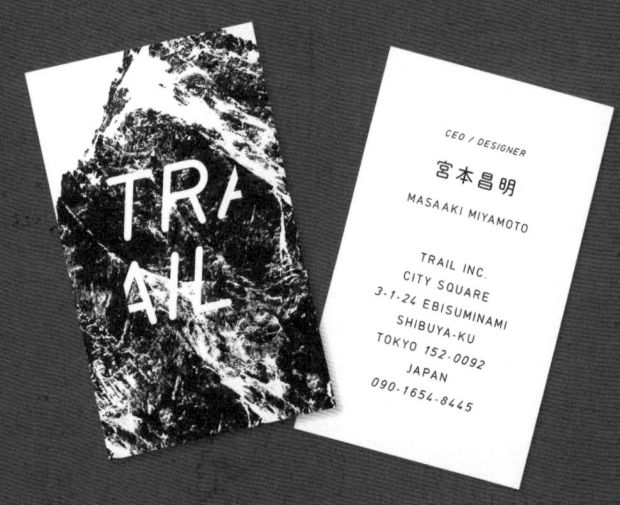

TRAIL　自社ツール / ポスター
TRAIL ［空間デザイン事務所　Space design］
AD, D, SB：emuni

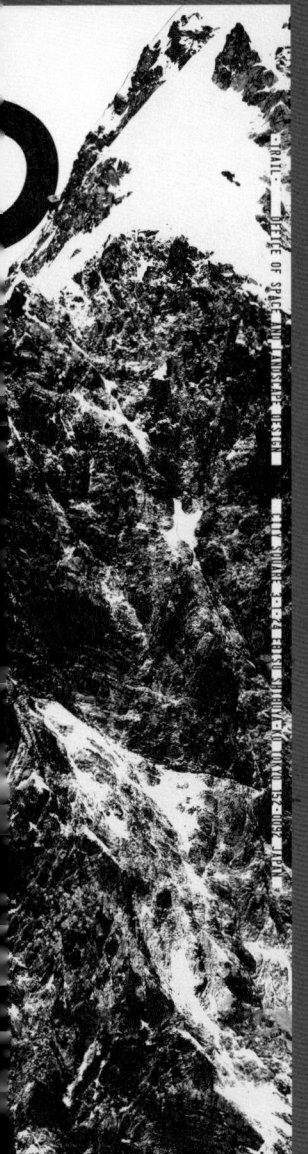

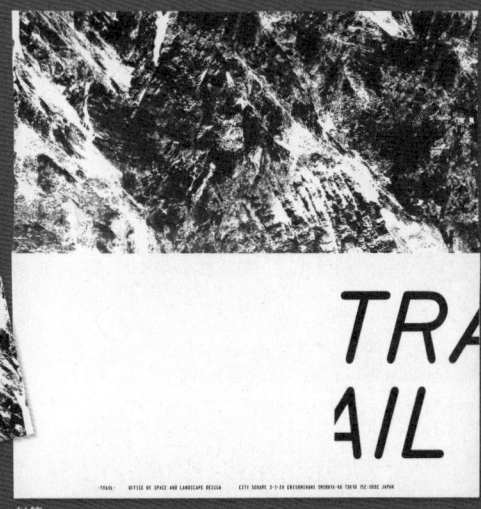

封筒

STYLISH & **COOL** 013

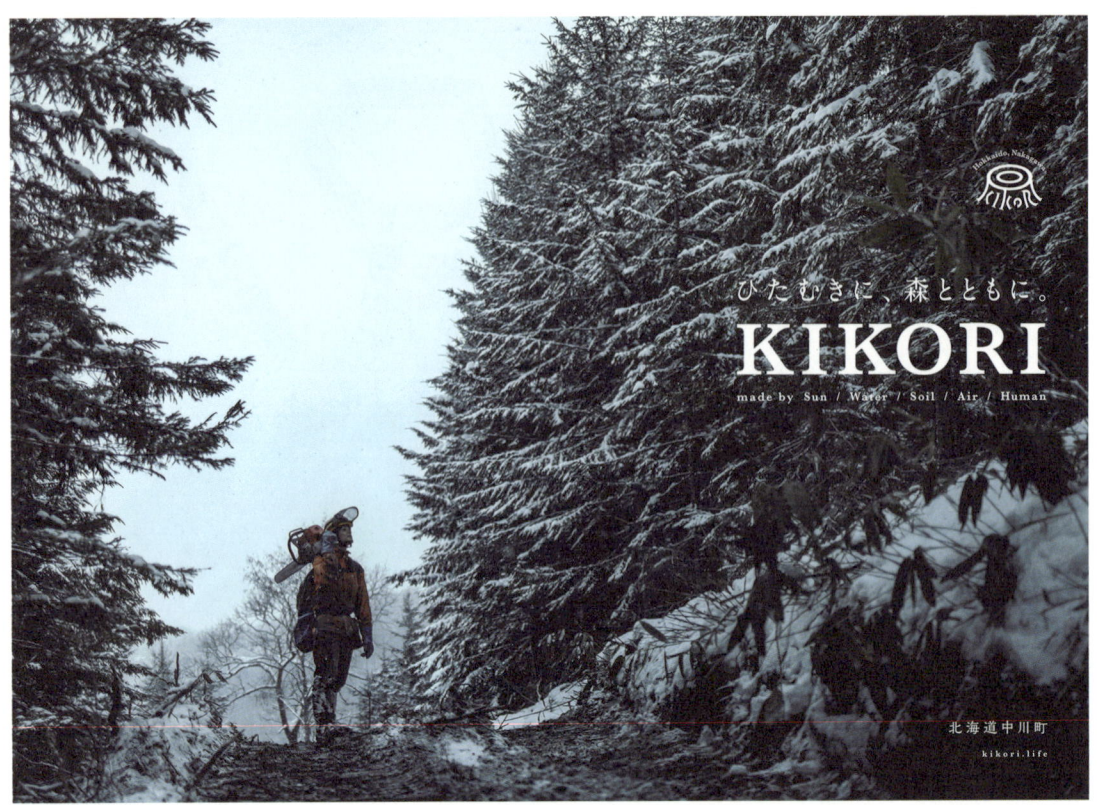
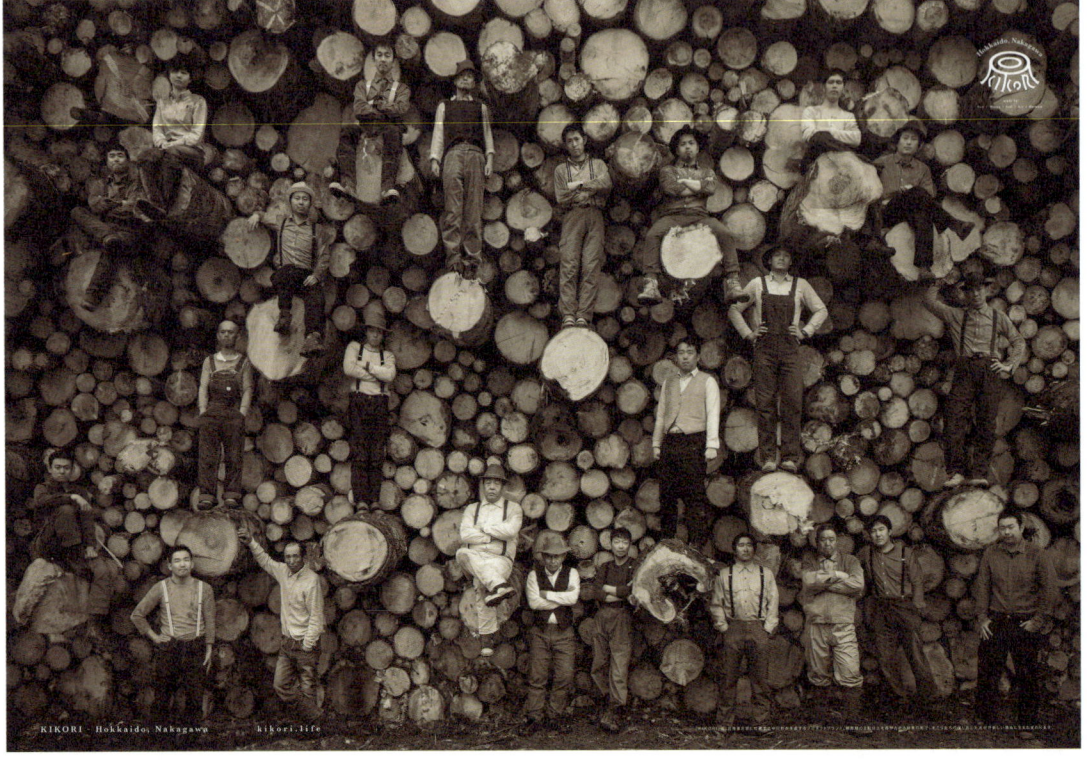

kikori シーズンポスター（冬・春）
中川町役場 ［役場 Town hall］
CD：寺島賢幸　AD,D：森川 瞬　P：佐々木育弥　CW：仲吉 蘭　プロダクトデザイナー：621（祐川 諭／植木 祐介／藤原 誠）　DF,SB：寺島デザイン制作室

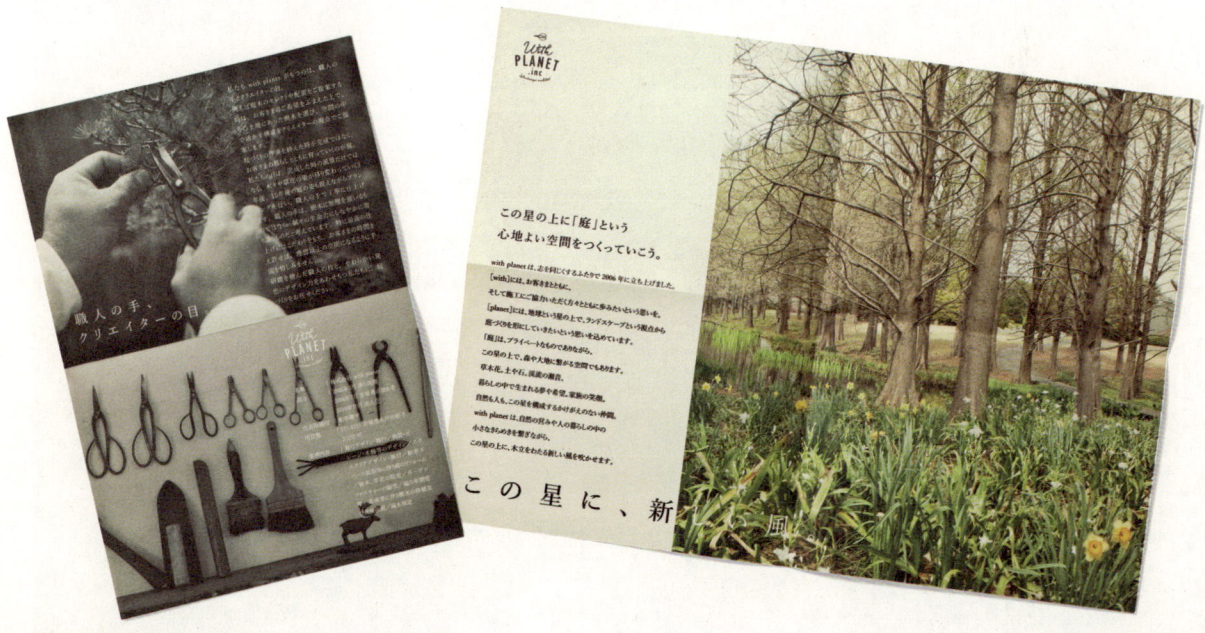

With Planet リーフレット
With Planet 〔造園業　Landscape gardening〕
AD, D：笹目亮太郎　SB：TRUNK

STYLISH & COOL　015

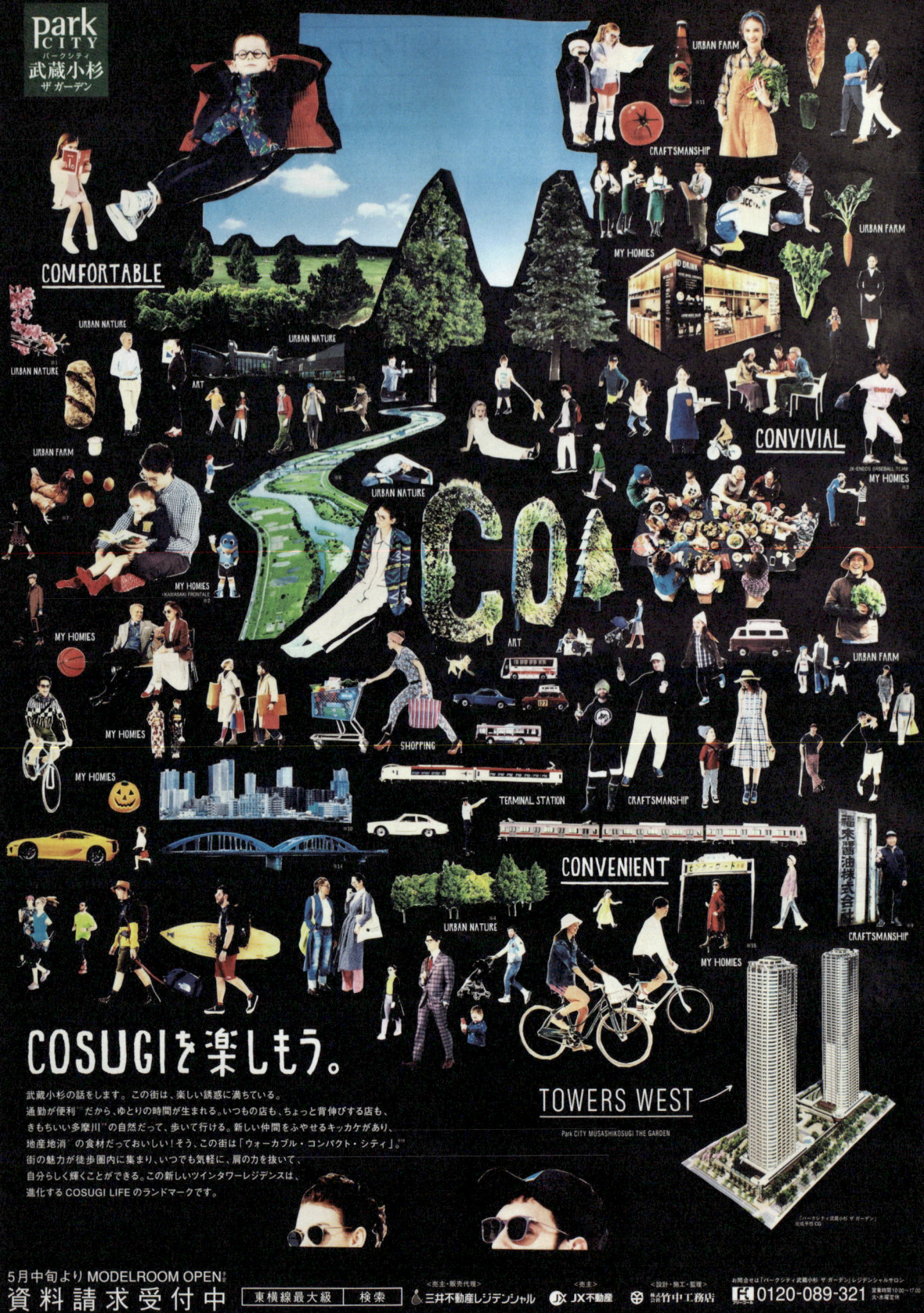

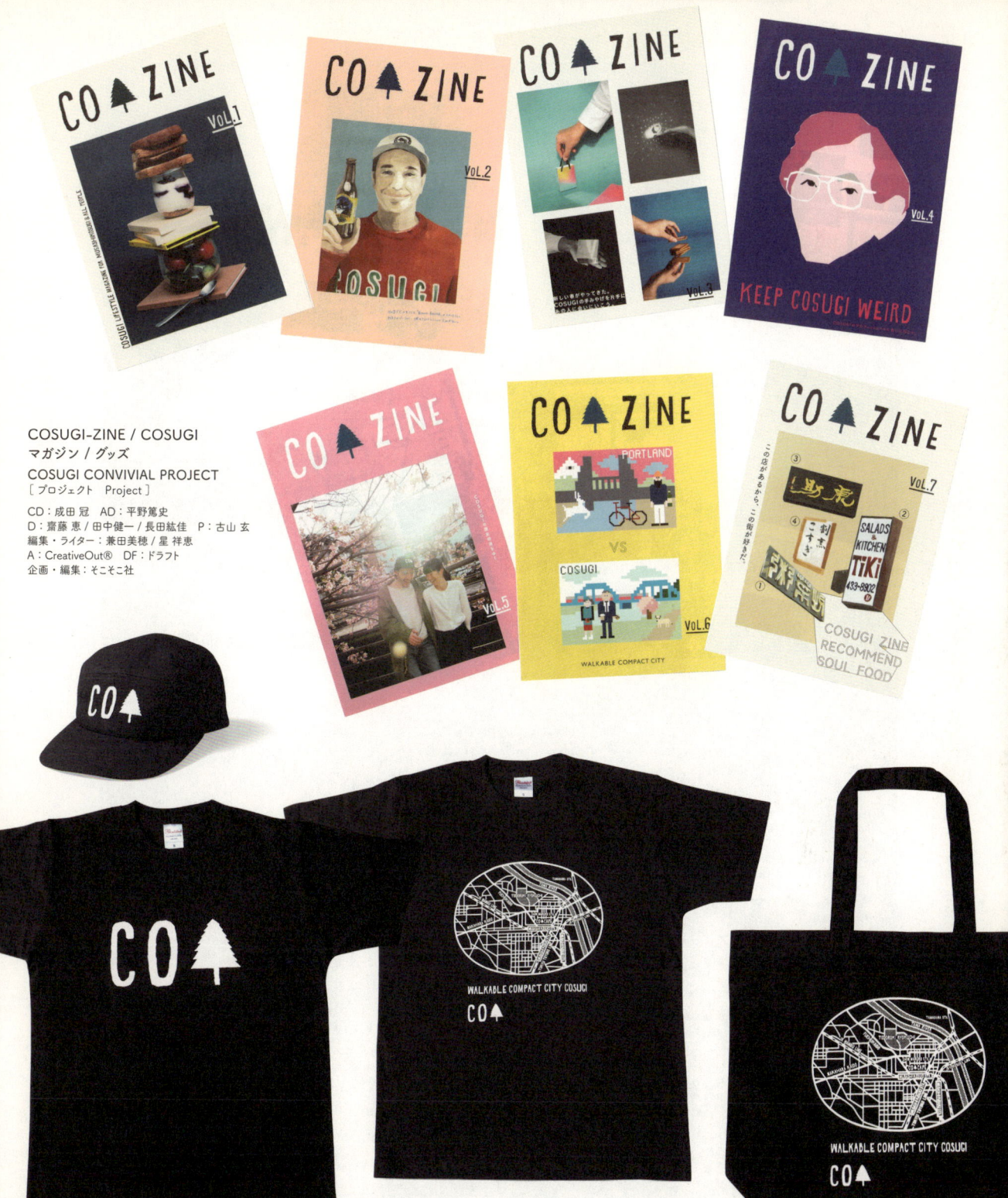

COSUGI-ZINE / COSUGI
マガジン / グッズ
COSUGI CONVIVIAL PROJECT
〔プロジェクト　Project〕
CD：成田 冠　　AD：平野篤史
D：齋藤 恵 / 田中健一 / 長田紘佳　P：古山 玄
編集・ライター：兼田美穂 / 星 祥恵
A：CreativeOut®　DF：ドラフト
企画・編集：そこそこ社

パークシティ武蔵小杉 ザ ガーデン　チラシ
三井不動産レジデンシャル / JX不動産〔不動産　Real estate〕
CD：成田 冠　　AD：平野篤史　D：齋藤 恵 / 田中健一 / 長田紘佳　P：福岡秀敏
CW：進藤伸二 / 大場祐子 / 菅原直人　A：CreativeOut®　DF：ドラフト　SB：広和

STYLISH & COOL　017

"NEWMAN" averts mass production and materialism.

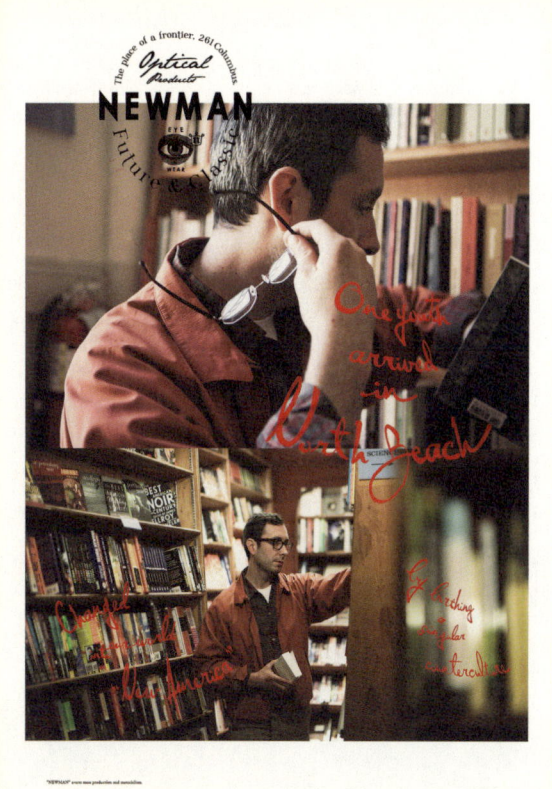
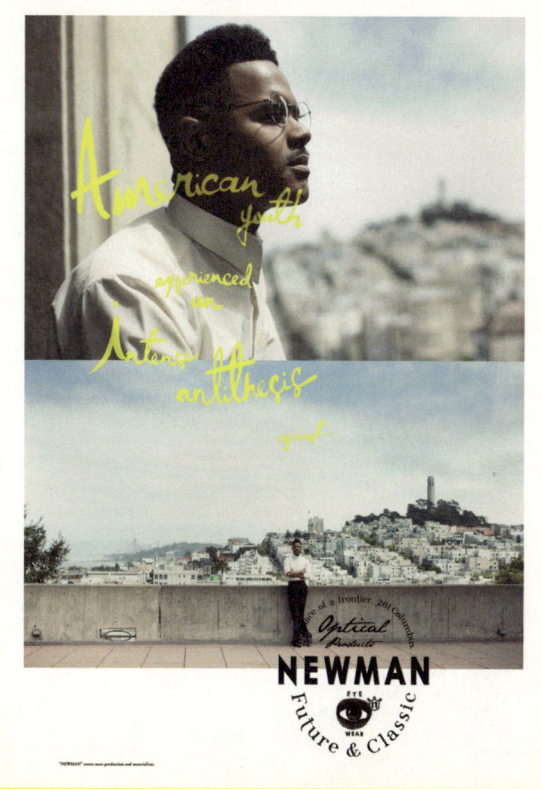
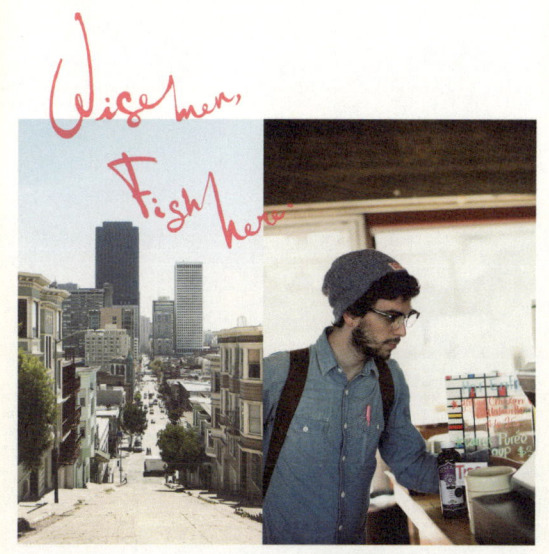

NEWMAN　ポスター
NEWMAN［アイウェアブランド　Eyewear］
CD, AD, D, DF, SB：balance inc.　P：仲尾知泰（Ripcord）　スタイリスト：片倉康行（huit）

CONVERSE SKIDGRIP 2014 AW AD　ポスター / カタログ
CONVERSE FOOTWEAR ［ シューズブランド　Footwear ］

CD, AD：吉田芳洋　AD：菊池志帆　D：東 さや香 / 玉川克人　P：OSAMU MATSUO（STUH）
スタイリスト：AYAKA ENDO（TRON）　ヘアメイク：YOSHIKAZU MIYAMOTO（perle）　DF, SB：ネンデザイン

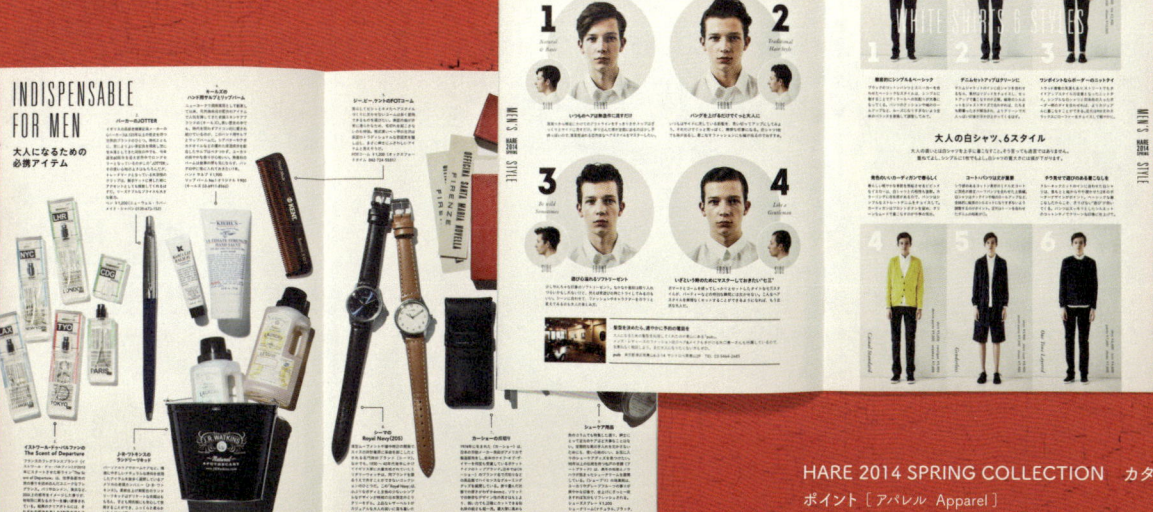

HARE 2014 SPRING COLLECTION　カタログ
ポイント［アパレル　Apparel］
AD, D：渋井史生　P：澤田健太　I：竹田嘉文　編集：Rhino
DF, SB：PANKEY

STYLISH & COOL　021

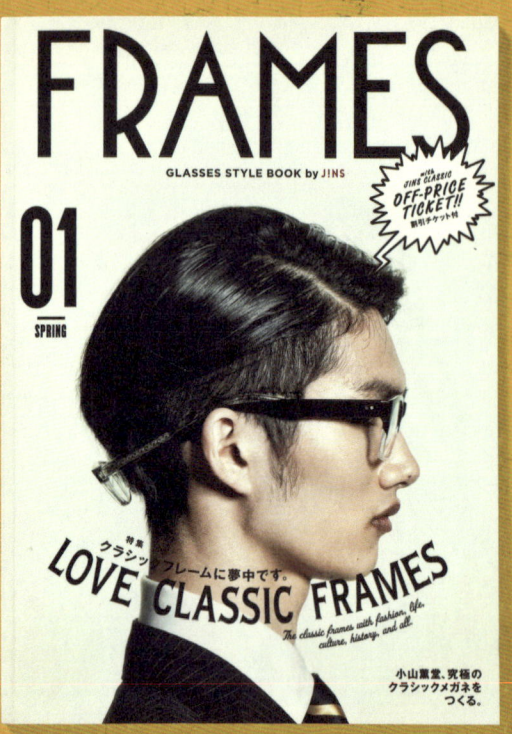

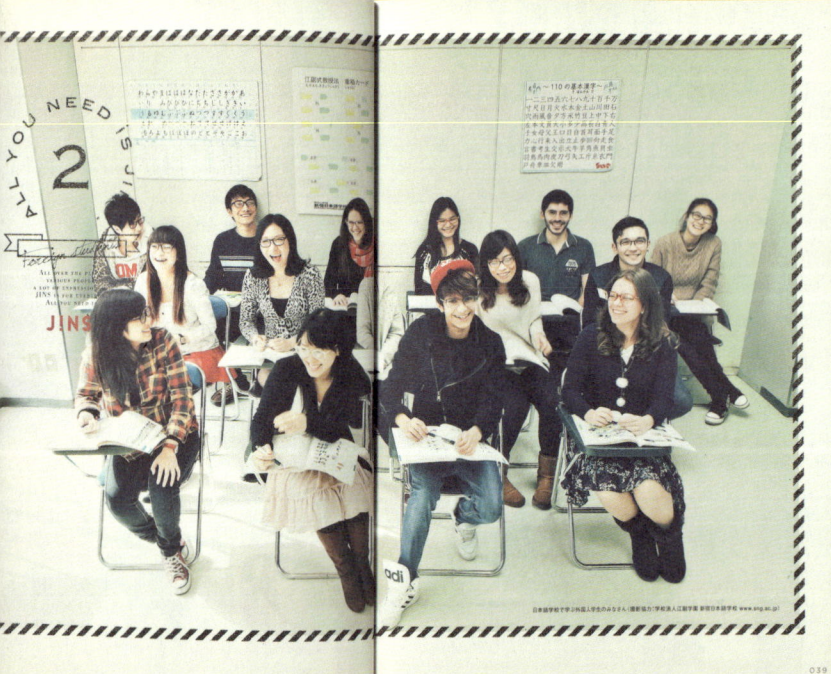

J!NS FRAMES 01　カタログ
ジェイアイエヌ［－アイウエア事業　Eyewear］
AD：前川朋徳（Hd LAB）　D：髙橋淳一（Hd LAB）　P：石黒幸誠（go relax E ware）　DF, SB：Hd LAB

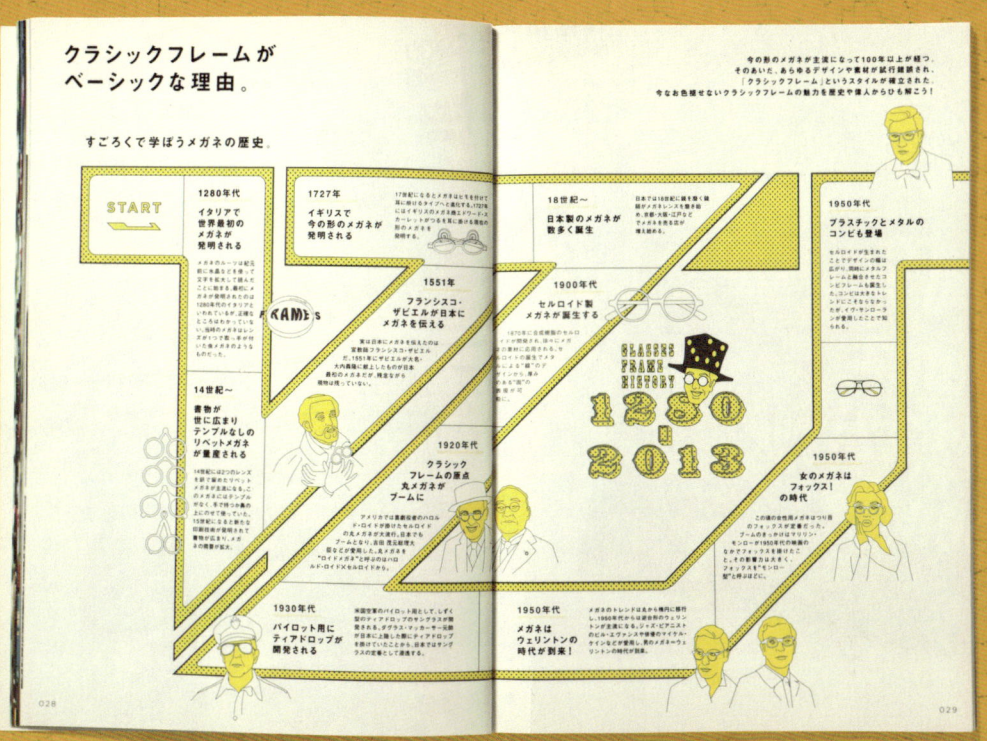

STYLISH & COOL 023

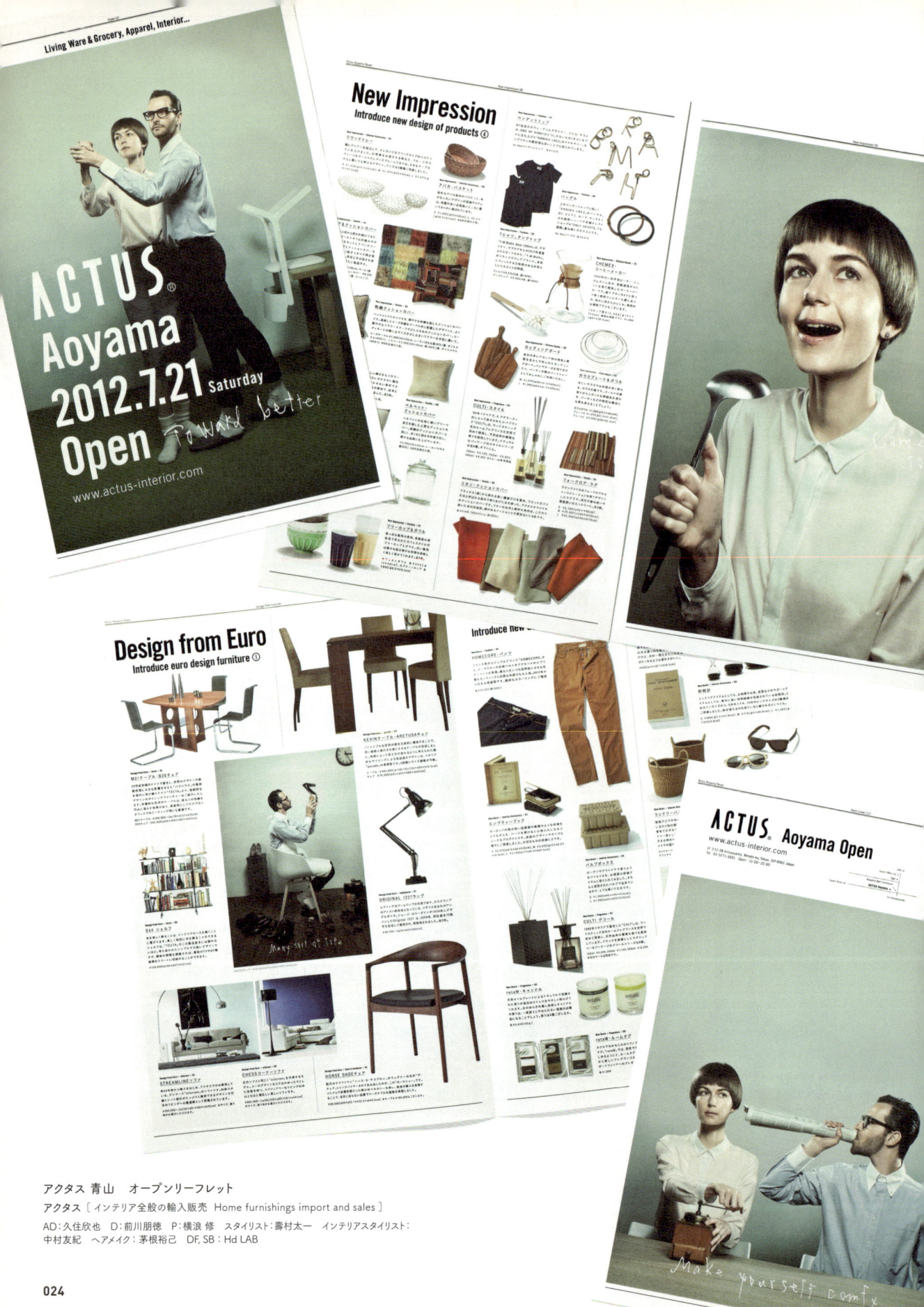

a

Stola JOURNAL 2015 Autumn vol.4　カタログ
アイア ［アパレル Apparel］

CD：影山直美（Mo-Green）　AD：永野有紀（Mo-Green）　D：亀卦川陽子（Mo-Green）／戸部真弓（Mo-Green）
P：横浪 修（表紙）／和田裕也（ROOSTER）＜a＞／古家佑美（SORANE）＜スチール＞　編集：宮崎愛子（Mo-Green）
モデル：anni jurgenson（WIZARD）　SB：Mo-Green

STYLISH & COOL　025

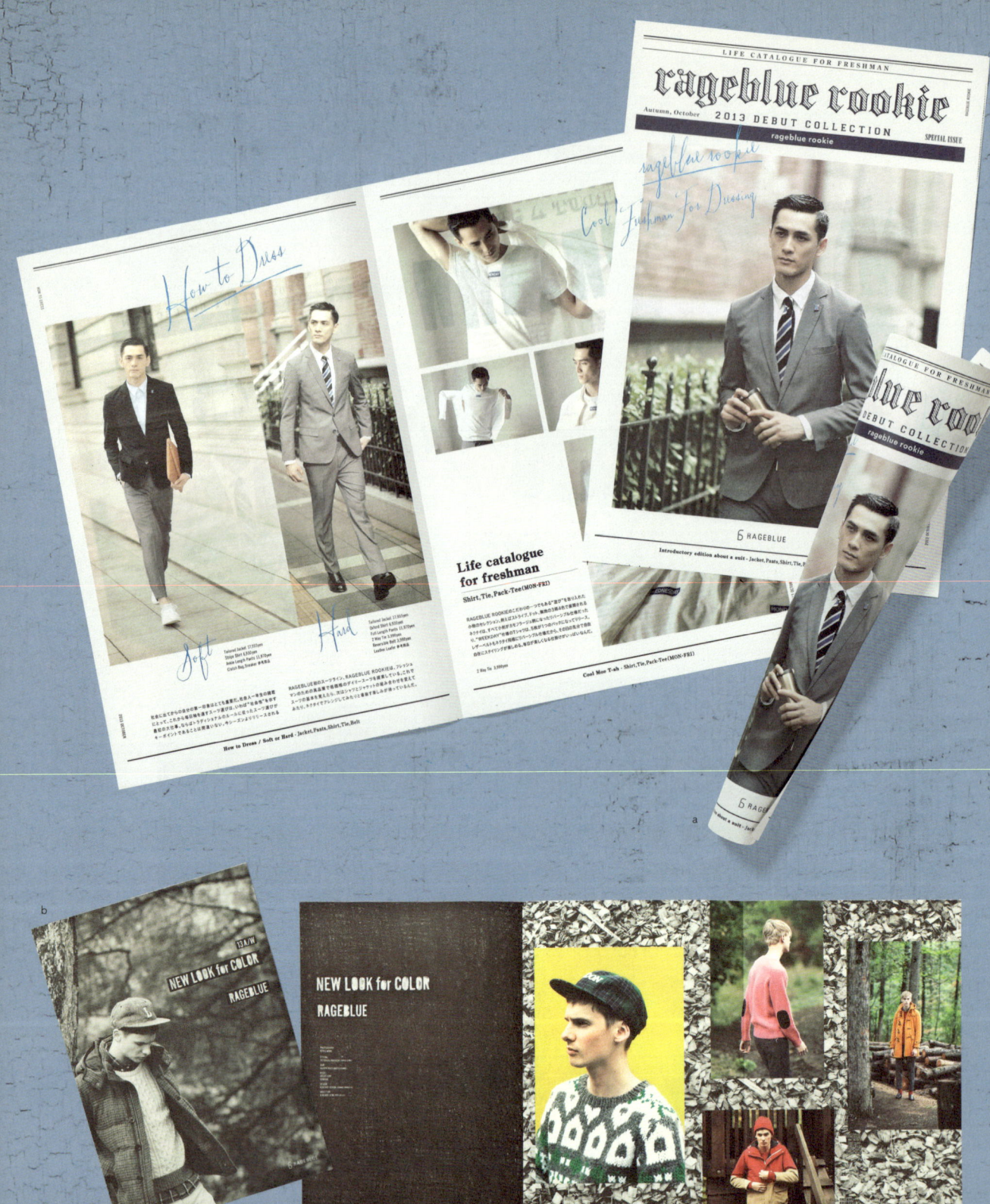

RAGEBLUE 2013 rageblue rookie タブロイド（a）/ 2013秋冬カタログ（b）
ADASTRIA ［衣料品・雑貨等の企画・製造・販売 Planning, manufacturing and sales of clothing and miscellaneous goods］
CD, AD：上野 健太郎　AD, D, SB：押見健太郎　スタイリスト：中石達宏　P：森 健人／大志摩 徹（a）

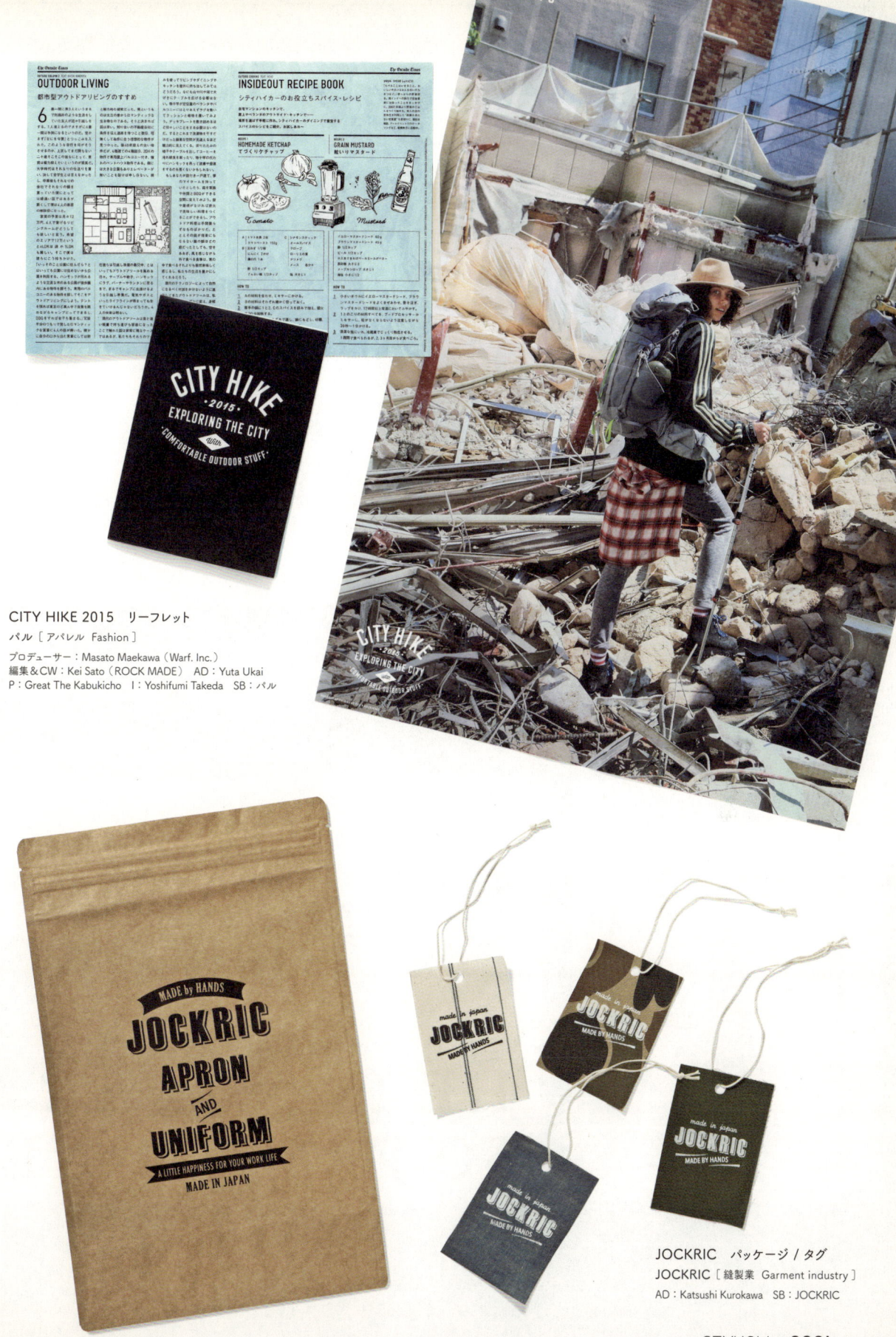

CITY HIKE 2015　リーフレット

パル［アパレル　Fashion］

プロデューサー：Masato Maekawa（Warf. Inc.）
編集＆CW：Kei Sato（ROCK MADE）　AD：Yuta Ukai
P：Great The Kabukicho　I：Yoshifumi Takeda　SB：パル

JOCKRIC　パッケージ / タグ
JOCKRIC［縫製業　Garment industry］
AD：Katsushi Kurokawa　SB：JOCKRIC

STYLISH & COOL　027

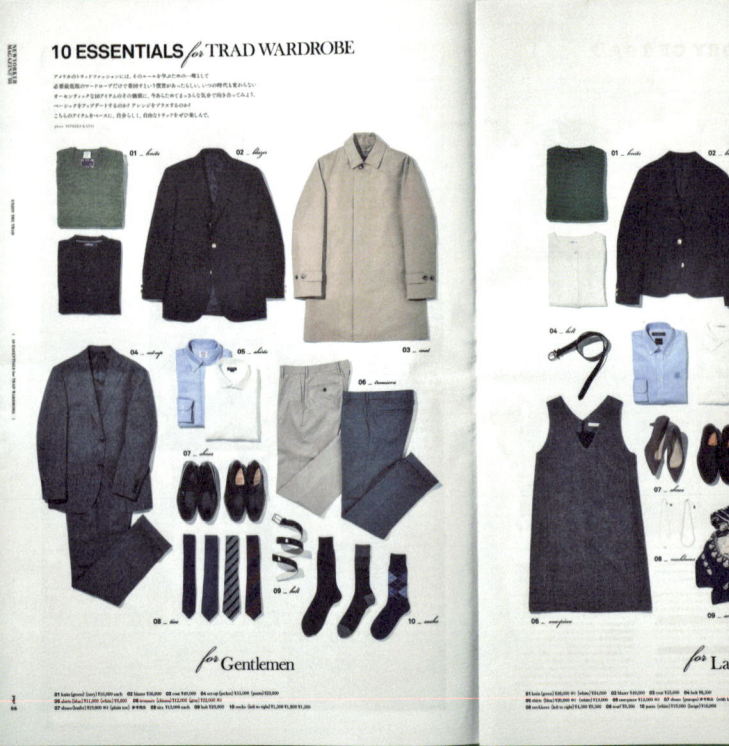

NEWYORKER MAGAZINE No.03　タブロイド
ニューヨーカー［既製紳士服・婦人服の企画・販売　Ready-to-wear apparel planning ／ sales］
AD：中村圭介　D：吉田昌平／樋口万里　P：松本昇大／加藤佳男　I：山口洋佑　編集：ライノ　DF, SB：ナカムラグラフ

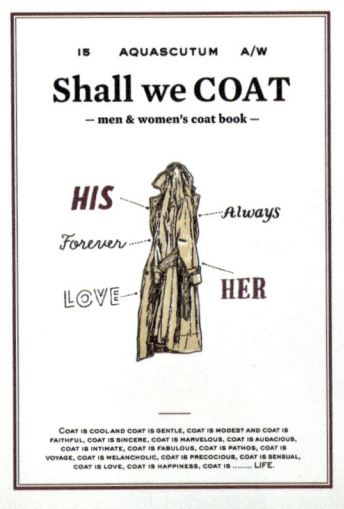
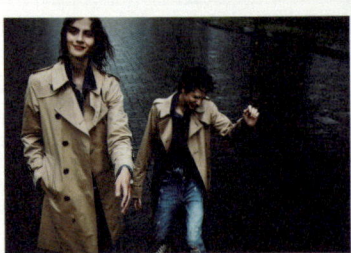

15 AQUASCUTUM A/W Shall we COAT　カタログ
レナウン［アパレル　Apparel］
AD：永野有紀（Mo-Green）　D：亀卦川陽子（Mo-Green）／戸部真弓（Mo-Green）
P：竹内裕二（S-14）＜a, b＞ I：Naohiga（c）　編集長：大草直子　編集：鈴木亜矢子（HRM）／MARIE／榎本洋子　SB：Mo-Green

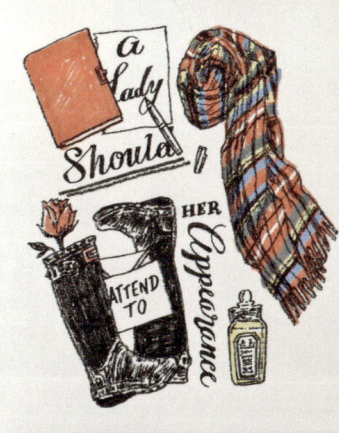

> There's no genders between love and fashion.

STYLISH & COOL 029

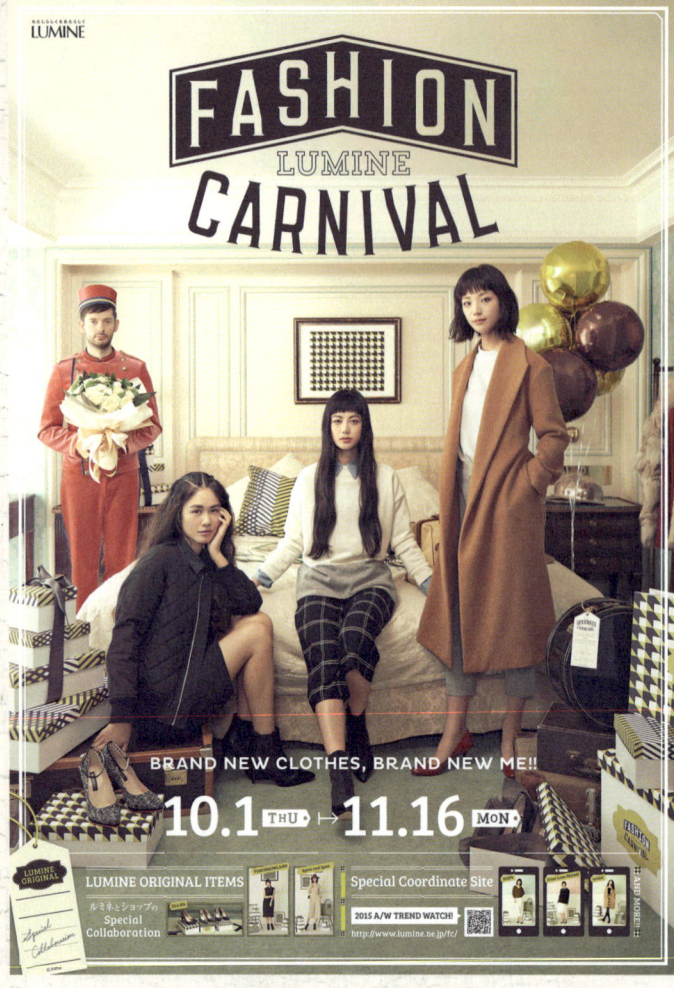

LUMINE FASHION CARNIVAL　キャンペーンポスター
LUMINE〔商業施設　Shopping mall〕
CD：R inc.　AD, D, SB：ANSWR　A：JR東日本企画

LUMINE横浜
New&Renewal SHOP告知ポスター
LUMINE横浜〔商業施設　Shopping complex〕
CD：アールシーケーティー　AD, D：タキ加奈子
P：山本雄生　A：JR東日本企画　SB：soda design

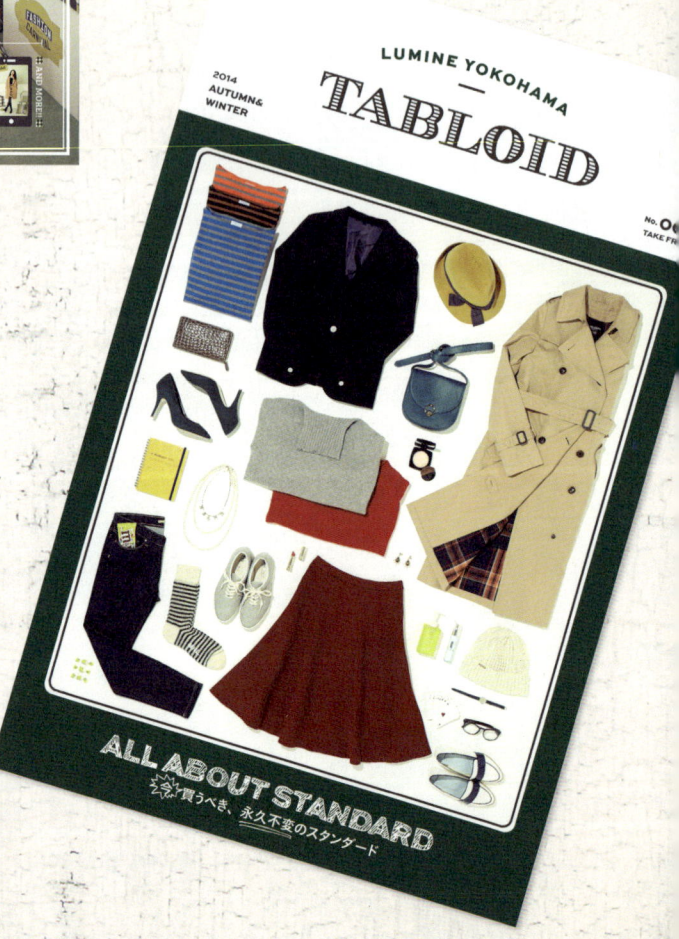

LUMINE横浜　タブロイド（季刊）TABLOID no.1
LUMINE 横浜〔商業施設　Shopping complex〕
CD：アールシーケーティー　AD, D：タキ加奈子　P：山本雄生
A：JR東日本企画　SB：soda design

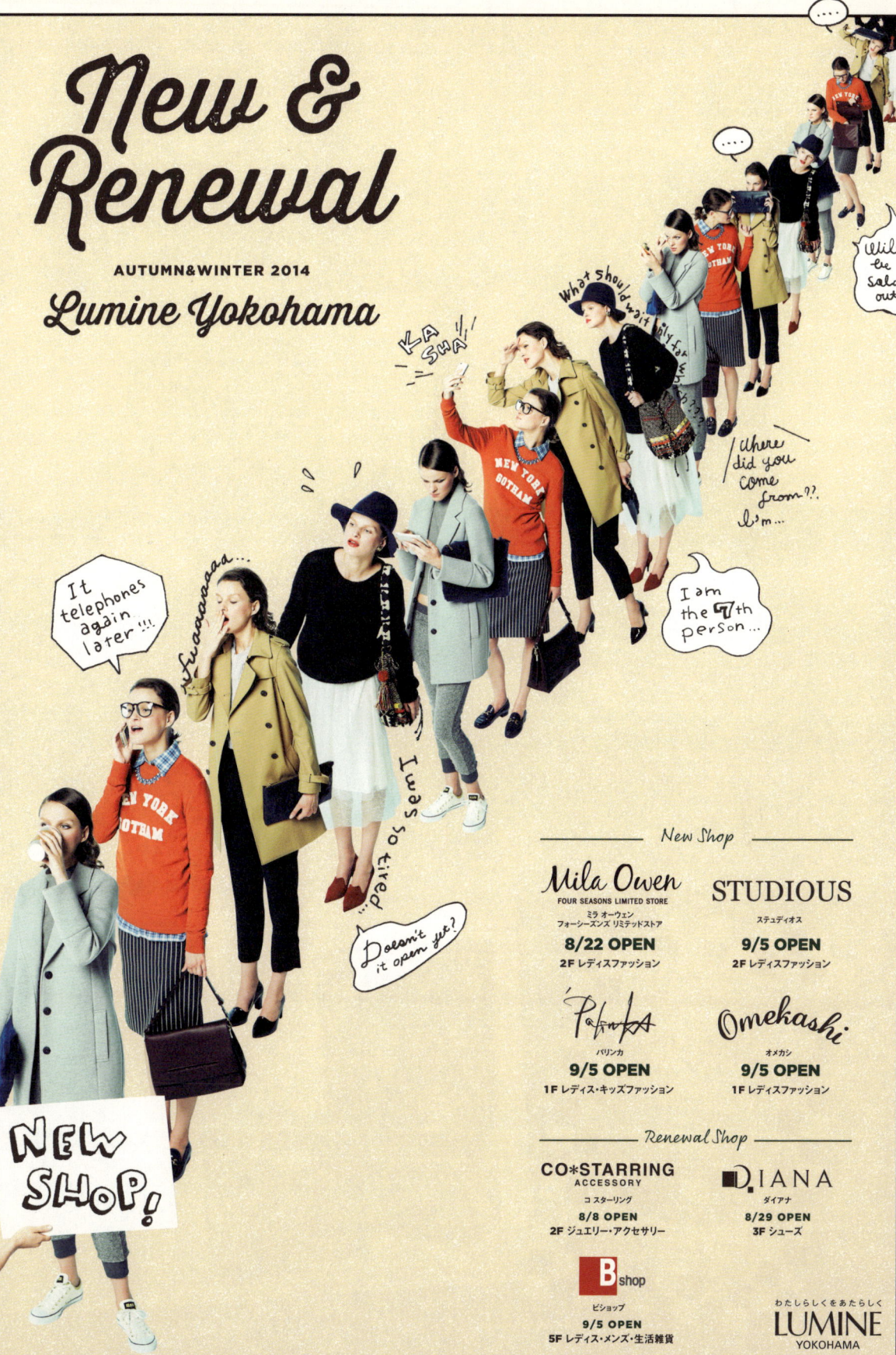

a

b

THE SUKIMONO BOOK　書籍
Mo-Green［デザイン事務所　Design firm］
CD：須藤 亮　AD：永野有紀　P：古家祐実（a）/ ISSEI（b）/ 野呂知功（c）/ 大志摩 徹（d）　ディレクター：永尾智憲（a, c, e）/ 三輪翔平（b, d）
セレクト：原田 学（a, b, c, e）/ 馬場圭介（d）　印刷所：瞬報社（a, c, e）/ 池田印刷（b, d）　発行人：森 克彦　DF, SB：Mo-Green

d

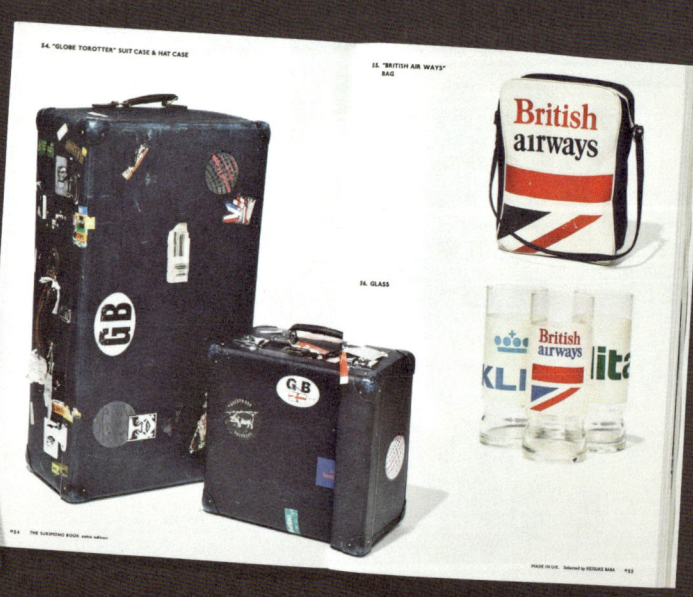

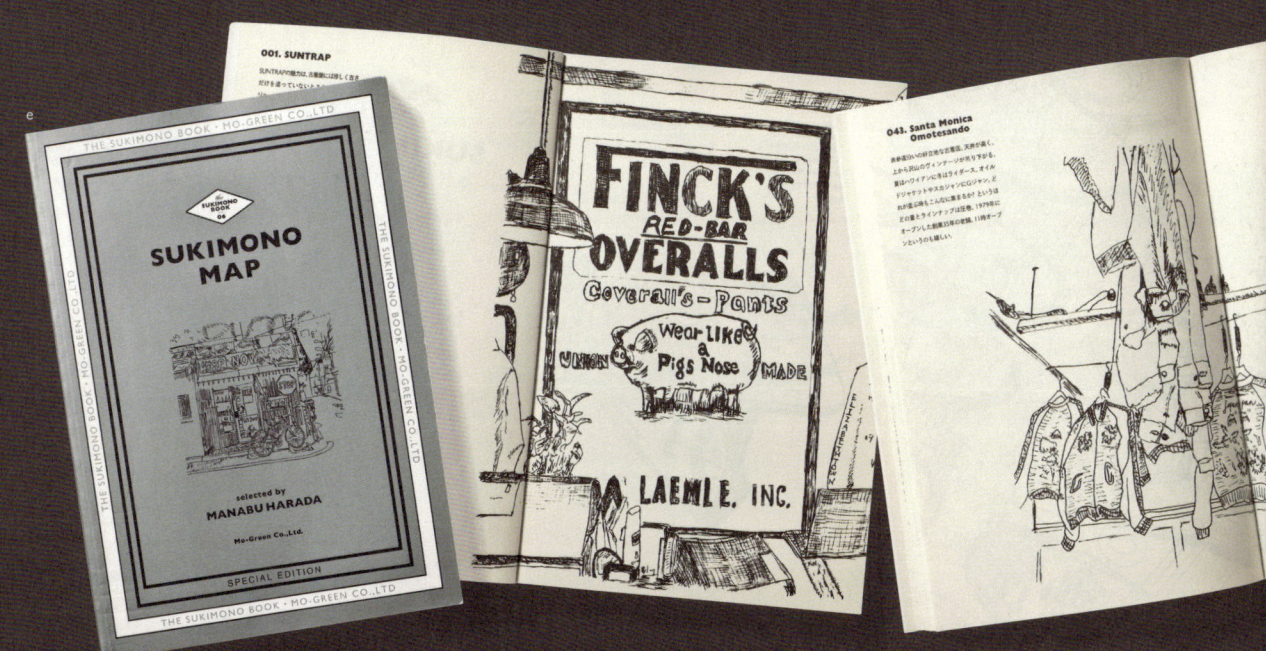

STYLISH & COOL 033

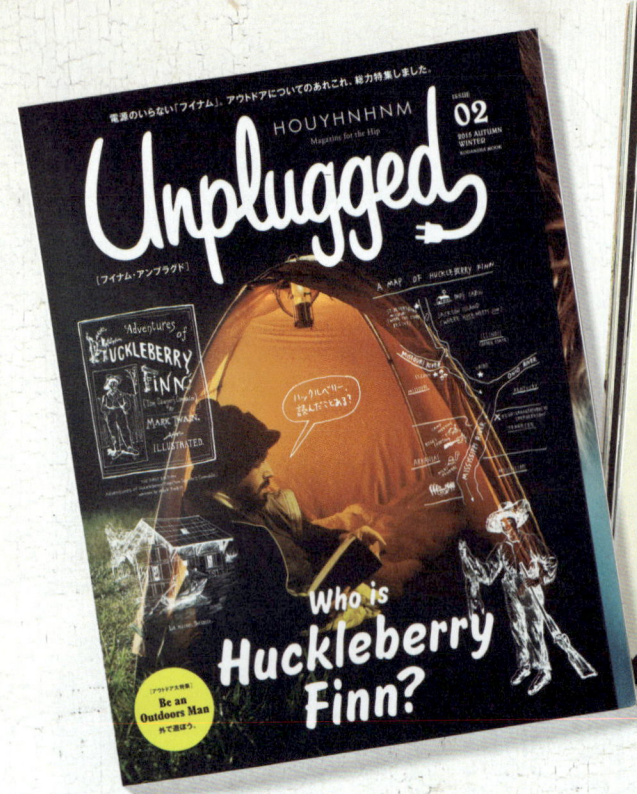

HOUYHNHNM Unplugged（フイナム・アンプラグド）Vol.2　雑誌
ライノ［WEB・雑誌の編集・発行　Web / magazine editing and publishing］
SB：ライノ

STYLISH & COOL 035

FISHMANS MARUYAMA　リニューアル告知ツール
（ポスター / フライヤー / メニュー）
FISHMANS MARUYAMA［飲食店　Restaurant］
D：野村ソウ　I：金浜玲奈　DF：STUDIO WONDER　SB：WONDER CREW

伊藤グリル　ポスター
伊藤グリル［西洋料理店　Restaurant］
AD, D：植松達馬　I：SATOCO　SB：ADESTY

焼き菓子パッケージ
graf studio kitchen ［飲食店　Restaurant］
D, SB：赤井佑輔（paragram）

STYLISH & COOL

Galo KITCHEN Restaurant branding　レストランブランディングツール
Galo KITCHEN ［飲食店　Restaurant］
P：Caroga Foto　CD, AD, CW, I, DF, SB：Anagrama

STYLISH & COOL 041

Cervecería de Colima　Product Branding　プロダクトブランディング
Cervecería de Colima［ビール醸造　Brewery］
P：Caroga Foto　CD, AD, D, CW, I, DF, SB：Anagrama

富川家　結婚式ツール
富川直貴・理花［個人　Personal］
AD, D, SB：押見 健太郎

042

THE CUTLERY OF MONOPURI　パッケージ
モノプリ［印刷プロジェクト　Printing project］
AD：高谷廉　D, SB：AD&D　SELECT：501 DESIGN STUDIO

STYLISH & COOL　043

RITARU COFFEE　パッケージ / ショッパー / ショップカード
RITARU COFFEE［カフェ & ロースター　Café / coffee roasters］
CD, AD, D, DF, SB：COMMUNE　プリンティングディレクター：佐藤麻奈美 / 近藤篤祐

NicoTable　会報誌
ABCクッキングスタジオ［料理教室　Cooking school］
CD：須藤 亮（Mo-Green）　AD：永野有紀（Mo-Green）
D：松本敦子（Mo-Green）／井坂真弓（Mo-Green）
P：小尾淳介　編集：石井菜穂子（Mo-Green）／
佐藤香織（Mo-Green）／横田可奈（Mo-Green）　SB：Mo-Green

STYLISH & COOL　045

B&B　Brand Identity　ブランドアイデンティティ
Oddds ［デザイン会社　Design firm］
CD, AD, D, CW, I：Reinold Lim　CD, AD, D, CW, P：Sarah Tan　DF, SB：Oddds

046

koffe　包装紙 / LIQUID COFFEEパッケージ
koffe［スペシャルティーコーヒーの焙煎店　Specialty coffee roasters］
CD：山中康次 / 山中彩子　AD, D：宮田裕美詠　DF, SB：ストライド

有機ルイボス茶　パッケージ
ルイボス製茶［製茶業　Organic rooibos tea］
AD, D：植松達馬　SB：ADESTY

STYLISH & COOL　047

tebito　ポスター
てびと［制作会社（WEB、映像その他） Production company（web/video）］
AD, D：カイシトモヤ　I：祖田雅弘　DF, SB：ルームコンポジット

LIFE IS JOURNEY　自主制作フライヤー
soda design［デザイン会社　Design Firm］
AD, D：柴田ユウスケ　Design Studio, SB：soda design

048

LIFE IS JOURNEY

2015
04.15 WED

LAST EXHIBITION

04.18 SAT

LUNCH TIME
11:30 — 14:00

DINNER TIME
18:00 — 22:00

CHIKA MIYATA
HAYATO KAZAMA
KANAKO TAKI
MASAHIKO SETOYAMA
MAYUMI OZAWA
SAIKO SHIIKI
SHOGO SEKI
SHOGO TAKEBAYASHI
TAKAYUKI KUDO
TOSHIYUKI HIRANO
YURICAMERA
YUSUKE SHIBATA

PLACE
bistro confl.
http://www.bistro-confl.com

タオルのアトリエ。
ウメアオイ

by Hotman

UMEAOI

タオルのアトリエ。
ウメアオイ

by Hotman

UMEAOI

ステッカー　　　パンフレット

UMEAOI　ブランディングツール
ホットマン［繊維製品の製造・加工および販売　Textile products manufacture and sales］
CD, AD：柿木原政広　　CD, CW：李 和淑　　AD, D：河村まゆみ
エグゼクティブプロデューサー：川島蓉子　　P：本城直季　　DF, SB：10

STYLISH & COOL　051

monotribe　会社案内
monotribe ［ Web 制作会社　Web production ］
AD, D, SB：emuni

MATSU SHIMA MOTOR SHOW

MATSUSHIMA MOTOR SHOW 2014

2014.10.11 SATURDAY
-10.12 SUNDAY 2DAYS
Kyoto International Conference Center
Event Hall [New Car] Parking [Used Car]
Official Website : matsushima-hd.co.jp

マツシマホールディングス　ポスター / インビテーション
マツシマホールディングス［高級輸入車の総合ディーラーカンパニー　Import luxury cars-dealers］
CD：吉田 豊　AD：小野恵央　D：木村高典／内海徹也／崎山龍晴　CW：横川謙司／関 俊洋　A、SB：電通

STYLISH & COOL　053

THE UNION PARK　ポスター
WELL JAPAN inc.［アミューズメントパーク　Amusement park］
AD, D, SB：emuni

POP & COLORFUL

トマト缶は売っていません。メガネを売っ

新しいスーパーマーケット型メガネ店、自由が丘にOPEN！

Zoff MART

Zoff MART JIYUGAOKA　ポスター（交通広告）
インターメスティック［アイウェア Eyewear］
CD, AD, D：千原徹也　CW：小樂 元（meet&meet）　SB：れもんらいふ

ます。

JIYUGAOKA
2015.12.4 fri OPEN

BODY FANTASIES ポスター
FITS CORPORATION K.K. 〔香水・化粧品会社　Perfumes / cosmetics〕
CD：野崎雅人　AD, D, SB：emuni　P：神宮巨樹　スタイリスト：内澤 研　A：ムサシノ広告社

CHUCKS SISTERS 2015SS　ポスター
CONVERSE FOOTWEAR［シューズブランド　Footwear］
CD, AD：吉田芳洋　CD：菊池志帆　D：東 さや香 / 玉川克人　P：MITSUAKI MURATA（TRON）　スタイリスト：AYAKA ENDO（TRON）　DF, SB：ネンデザイン

miwa concert tour 2013 Delight　グラフィック / グッズ
トライストーン・エンタテイメント［芸能事務所　Talent office］
AD, D, SB：emuni

060

Chucks
SISTERS

POP & COLORFUL

今度のは、
どんな味だと
思います？

KIWI IPA

秋限定。「十六夜」と書いて、「いざよい」と読みます。

マイ・ファニー・レディ　映画パンフレット
彩プロ ［映画宣伝 / 配給　Film publicity / distribution］
AD, SB：大島依提亜　D：中山隼人

グランドキリン 十六夜の月　ポスター
キリンビール［酒類事業　Beverages］
CD：前田知巳　AD：細川 剛
D：久保有輝／楳村秀冬　P：児島孝宏
CW：前田知巳　制作会社：博報堂プロダクツ／フューチャーテクスト
A, SB：博報堂　DF：ツープラトン

遊 中川　きり飴　パッケージ
中川政七商店［雑貨の製造・小売　Houseware production and sales］
D：岩井美奈（中川政七商店）　SB：中川政七商店

POP & COLORFUL　063

キリン ハードシードル　ポスター
キリンビール［酒類の製造　Beverage manufacturer］
CD：澁江俊一　AD：堤 裕紀　D：小林るみ子　P：青山たかかず　I：土谷尚武　CW：中村眞也 / 姉崎真歩　DF：CREATIVE POWER UNIT　SB：電通

064

SPRING VALLEY BREWERY　パッケージ
SPRING VALLEY BREWERY［ビール醸造　Brewery］
SB：SPRING VALLEY BREWERY

UNA TEA　パッケージ / ペーパーバッグ
ウナ［製茶業　Tea］
CD, AD, D：小野圭介　　P：鈴木陽介　　WEBデザイナー：杉江裕視　　DF, SB：ONO BRAND DESIGN

POP & COLORFUL　065

Cidre min. フリーペーパー
スターツ出版〔出版社 Publishing〕
AD, D, SB：emuni　I：三上数馬

箕面ビール　商品ラベル
箕面ビール〔ビール・発泡酒製造　Brewers〕
SB：箕面ビール

POP & COLORFUL

イトキトのフレンチスタイルサンドイッチ　書籍
マイナビ出版 ［出版社 Publishing］

SB：マイナビ出版　著者：itokito 勝野真一

POP & COLORFUL

ラッピングペーパー

ULTRA HEAVY　展覧会ツール / 商品
ULTRA HEAVY〔No industry〕
SB：ULTRA HEAVY

070

071

NIXON×mini　ポスター / 雑誌誌面
宝島社 / ニクソン　[出版社 / アパレル　Publishing / Apparel]
D：蒲生和典　　P：ARATA SUZUK（go relax E more）　I, DF, SB：GRAPHITICA
ヘアメイク：MEGUMI KATO　　スタイリスト：MIHO ASHINO　　モデル：ERIKA MORI

072

ReTHINK　フリーマガジン
TABI LABO
［インターネット上でのメディア事業 / 広告制作販売
Internet-based media / advertising］

AD：Akiko Shiratori / Satoshi Shibata
P：Yoshihiro Miyagawa / Shino Chikura　I：MACCHIRO
CW：Yoichi Murakami / Kenji Oshima / Seiya Fuchigami / Fumie Nakamura
SB：TABI LABO

POP & COLORFUL　073

アトリエドゥ サボン 2013A&W カタログ
AMBIDEX［アパレル Apparel］
CD, AD：千原徹也（れもんらいふ）　P：レスリー・キー　スタイリスト：飯嶋久美子（IUGO）　ヘアメイク：奥平正芳（CUBE）　SB：れもんらいふ

074

TEN NIGHTS OF DREAMS

l'atelier du savon

fig London peu près laml didizizi

AUTUMN & WINTER 2013

- The first night — MODEL KANOCO
- The second night — STUDENT MISORA OYAMA
- The third night — MODEL YIran
- The fourth night — SINGER SAKI KANAZAWA
- The fifth night — PRESS AYAKA OBA
- The sixth night — BLOGGER NATSU-YOU
- The seventh night — DANCE PERFORMER YOKO HONDA
- The eighth night — HOUSEWIFE TSURU KAWAGUCHI
- The ninth night — MODEL & DESIGNER KIKUNO KUNIHARA
- The tenth night — ACTRESS & MODEL TENKO

第2夜 — The second night

午後4時、夢を見る私の夢を見た。
確かに何かの夢を見ていた。とてもとても深い夢。
夢の中で見つけたもうひとつの自分はとても似ていて、
いい夢を見ているようだった。もうひとつの自分を見つけていると
意識はスルリともうひとつのものへとうつる。
そのひとつ夢で見つけたきらにもうひとつのものをもうと思っていて
いつまでたっても夢を見ると夢を見つけていた。

STUDENT MISORA OYAMA (12)

大山みそら

blouson ¥44,1000 am 0
t-shirt ¥7,245(didizi)
skirt ¥18,690(peu près)
sox ¥1,890(l'atelier du savon)
booties ¥14,490(didizi)
bag ¥15,5400 am 0
ring ¥4,095(didizi)

第8夜 — The eighth night

午後1時3分、あの人との結婚式の夢をみた。
微かに聞こえた時報、秘姫はそこから…

HOUSEWIFE TSURU KAWAGUCHI (88)

川口つる

coat ¥40,950(am 0)
one-piece ¥22,050(l'atelier du savon)
tights ¥6,090(didizi)
shoes ¥13,440(didizi)
ring ¥2,625(didizi)
earring ¥3,360(didizi)

POP & COLORFUL 075

076

ROPÉ PICNIC　2014 SPRINGタブロイド / カタログ / ブランドブック
JUN［アパレル　Apparel］

CD：小西利行　AD：岩崎悦子　D：沖田佳奈　P：半沢 健
I：山本祐布子　CW：小林麻衣子　SB：POOL inc.

POP & COLORFUL　077

SUNNIESTA　パッケージ / ポスター
BAM ［グラフィック / ファッション / ファニチャー　Graphics / fashion / furniture］
DF, SB：BAM

ポスター

078

フジファブリック　FAB LIFE BOX
Sony Music Artists
［アーティストマネジメントおよびレーベル事業　Music label / artist management］
AD, D：いのうえよしひろ　　DF, SB：ジョットグラフィカ

JAGDA NEW DESIGNER AWARDS EXHIBITION　展示告知ポスター　日本グラフィックデザイナー協会［デザイン協会　Design association］
AD, D, SB：白本由佳

ボルヴィック プラス ビタミン　ポスター
キリンビバレッジ［清涼飲料の製造・販売　Beverage manufacture and sales］
CD：山田尚武　AD：窪田新　D：北中陽 / 志胃岐香　P：松原博子　CW：中村眞也　A, SB：電通　DF：ジェ・シー・スパーク

POP & COLORFUL

Comuna Branding, Packaging　ブランディング / パッケージ
Comuna［飲食　Food］
CD：Iván García　A, SB：Futura

Personal project Package　個人作品パッケージ
Judit Besze［個人　Personal project Package］
SB：Judit Besze

オモハラギフトコレクション　フライヤー
東急不動産 ［不動産　Real estate］
AD：五木田裕之　D, DF, SB：サーモメーター

OPC HACK & MAKE AWARD 告知ポスター
オリンパス ［光学機器・電子機器　Optical and electronic equipment］
CD：寺井翔茉　AD, D：平野達郎　クリエイティブエージェンシー：ロフトワーク　SB：トロープ

COLLECTORS　2015SSカタログ
NEUVE A COLLECTORS（ヌーヴ・エイ　コレクターズ）［ファッション雑貨セレクトショップ　Fashion accessories boutique］
P：高野長英　I, DF, SB：セメントプロデュースデザイン

TAMEALS OTEMACHI　ポスター
コンセプション [飲食店　Restaurant]
AD：高谷 廉　DF, SB：AD&D　I：西田真魚

TiC TAC　2014SPRINGカタログ
NEUVE A TiCTAC（ヌーヴ・エイ チックタック）[時計セレクトショップ　Watch boutique]
D：林 里栄子　P：平田かい　I, DF, SB：セメントプロデュースデザイン

POP & COLORFUL.　087

メガネは顔です。

メガネってなんですか。見えにくいものを見やすくする道具？視力の低下をおぎなうアイテム？そりゃそうなんだけど、それだけじゃない。メガネは顔です。目、鼻、口、髪、肌。そのすべての要素が人の見た目をつくるでしょ。メガネもですよ。メガネが変わると顔が変わる。相手にあたえる印象も大きく変わる。なにせメガネは顔のいちばん前にあるものですから。メガネは「見え方」をつくるものですが、「見た目」もつくるんです。そのことを、もっと、ちゃんと、考えなくちゃ。メガネをもっとコーディネートしよう。メガネをもっと着替えよう。

2016.3.12.SAT SENSATIONAL OPEN

メガネからライフスタイルをつくるショップ「eyevory／アイボリー

オープニングスペシャル／レンズ50%OFF —3.12.SAT-4.11.MON— ●全レンズ対象 ●1本目
さらに、メガネをご購入の方に素敵なプレゼ

∞ メガネ Glasses　∞ サングラス Sunglasses
補聴器 Hearing Aid　コンタクト Contact Lens

〒573-1117　大阪府枚方市北船橋町30番　TEL・FAX 072-808-8910　OPEN10時〜19時半　www.eyevory.jp

eyevory　ポスター / DM
ビジョンメガネ
［眼鏡・コンタクトレンズの小売　Eyewear / contact lenses］
AD：森 裕崇　D：石川貴章 / 北村季暉　DF, SB：ヴォイス

Relaxed & NATURAL.

TEGAMISHA is coming to PORTLAND ポスター
手紙社 [飲食店の経営 / 雑貨店の経営 / イベントの企画 / 雑誌・書籍の出版 Restaurant / variety store management; event planning; publishing of books and magazines]
AD：川村哲司 D：古屋悦子 P：鈴木静華 DF：atmosphere ltd. SB：手紙社

TOKYO HOKUOUICH　ポスター

手紙社
［飲食店の経営 / 雑貨店の経営 / イベントの企画 / 雑誌・書籍の出版
Restaurant / variety store management;
event planning; publishing of books and magazines］

CD：手紙社　D：山本洋介　I：小池ふみ
SB：MOUNTAIN BOOK DESIGN

スペクテイター34号 BEAMS
雑誌広告
BEAMS［アパレル Apparel］
D, I：相馬章宏　SB：コンコルド・グラフィック

Relaxed & NATURAL.　091

Red Bull Music Academy Tokyo 2014 SINEWAVE SUNDAY　ポスター
Red Bull Music Academy ［アーティストたちを支援する世界的な音楽学校　Global Music Institution］
CD：ポストーク　AD：いすたえこ（NNNNY）　I, SB：林 洋介

Made in 北海道　ポスター
北海道ブランド発信PROJECT ［地域ブランド　Regional brand］
CD：服部展明　AD：八木 彩　D：下山佳世子／比嘉彩乃／水上香名子
CW：木下さとみ　DF：ジェ・シー・スパーク　A, SB：電通

JAGDA北海道　ポスター
JAGDA 北海道［デザイン団体　Design Association］
AD, D, I, DF, SB：COMMUNE［コミューン］

093

12-1 TODA, NASUSHIOBARA-SHI,
TOCHIGI-KEN 325-0114, JAPAN
www.toda.jp.net

AS IF WORKING WITH A GARDEN TROWEL...

T.O.
D.A.

ポスター

サイン

森をひらくこと、T.O.D.A.　ポスター / パンフレット / サイン
森をひらくこと、T.O.D.A.　[カフェ　Café]
AD, D : Ryosuke Uehara　　CD : Hideki Toyoshima
D : Natsumi Nakako　　AD : Yoshie Watanabe　　CW : Asaji Kato　　SB : KIGI

ポスター

Relaxed & NATURAL.　095

THE NORTH FACE COMPLETE FUJI WALKER　パンフレット
ゴールドウイン
［スポーツ用品の製造および販売　Sporting goods manufacture and sales］
CD：The Editorial Department Inc.（企画立案と編集）
AD, D：相馬章宏（Concorde Graphics）〈デザイン、中面の地図作画〉
P：三田正明（人物）　I：斎藤 融（表紙）　SB：ゴールドウイン

ステッカー

MIGHTRY ショップツール
MIGHTRY [アパレル Apparel]
CD, AD：井浦 新　CD：宮田 亮　AD, D, SB：押見健太郎

Relaxed & NATURAL.

098

LET'S CAMP!!
AT ROOFTOP

家でも、アウトドアを楽しむ。

アウトドアシーズンがやってくると、外遊び派の気分はやっぱりフィールドに向かってしまうけど、家でも大きな空の下で過ごすことができれば、いつでもアウトドア気分を味わえるはず。そんなアウトドア好きにとって理想のライフスタイルを実現してくれる「ヘーベルハウス」の3つの空間 "ルーフトップ" "そらのま" "そらから" をご紹介します。

Photo / Shouta Kikuchi Styling / Tomoyuki Sasaki Hair & Make / Misao Touyama
Model / Patricio, Tatsushi, Dean, Kalina, Kozue, Haru, Rei

程よい光と風を取り込みながら、外とゆるやかにつながる場所が「そらのま」。まるで室内のようなアウトドアプライベート空間に、立ち上がった屋根が外の視線を遮ってくれるので、開いた天井が心地よく、コットで子どもとのんびり過ごして、ゆっくりと時間を楽しみたい場所です。

植物に囲まれたガーデニングの場所としたり、食事やコーヒーを楽しんだり、空を眺めて子どもとお昼寝したり、自由な発想で使えるアウトドア派にとって理想の空間です。朝も昼も、夜も風を感じる空間が満足させてくれます。

そらのま BALCONY LIV...

旭化成ホームズ アウトドアリビング
カタログ / オリジナルマグカップ / コースター
旭化成ホームズ [住宅メーカー / 注文住宅 Home construction]
SB：旭化成ホームズ

Relaxed & NATURAL 099

旭化成ホームズアウトドアリビング
カタログ

Smart LOGOS vol.07　雑誌
ロゴスコーポレーション［アウトドア用品・アウトドアウエアなどの企画・販売・製造
Outdoor wear / equipment planning, production, sales］
AD：中村圭介　D：檜垣有希／清水翔太郎／伊藤永祐　P：松尾 修　I：越井 隆
編集長：唐澤和也（Punch Line Production）　ライター：星野早百合／栗栖周輔
LOGOSスタッフ：宮下貴弘／増田 琢／利本季隆／中井千容／福岡 彩　DF, SB：ナカムラグラフ

LOGOS 2016 セレクション　カタログ
ロゴスコーポレーション［アウトドア　Outdoor］
AD, D：渋井史生　P：三浦太輔　I：吉實 恵　編集：唐澤和也　DF, SB：PANKEY

Relaxed & NATURAL　101

アラスカの冬を旅して Winter Travel Guidance　パンフレット
コロンビアスポーツウェアジャパン
［アウトドア・スポーツウェアの製造・販売　Outdoor sportswear manufacture and sales］

AD, D：米山菜津子　P：森嶋一也（Alasuka）／清水健吾（Model／Product）　I：Artus de Lavlleon
ライター：小林百合子　モデル：杉浦文紀／KASUMI　スタイリング：八木智也　A：東京アドバタイジング
編集：ユーフォリアファクトリー　SB：コロンビアスポーツウェアジャパン

PAPER LOGOS　2013 vol.02 / 2014 vol.03 / 2015 vol.04　雑誌
ロゴスコーポレーション［アウトドア用品・アウトドアウエアなどの企画・販売・製造　Outdoor wear / equipment planning, production, sales］
AD：中村圭介　D：伊藤永祐／清水翔太郎／檜垣有希　P：関暁／三浦太輔／鈴木泰介　編集長：唐澤和也（Punch Line Production）　ライター：安部しのぶ　DF, SB：ナカムラグラフ

東京近郊ミニハイク　書籍
小学館［出版社 Publishing］
編集・文：若菜晃子　AD, D：矢部綾子（kidd）/ 小嶋香織
P：羽金知美　SB：小学館

Relaxed & NATURAL

105

LOCALS vol.01 NAGOYA　タブロイド
オンワード樫山 ［アパレル Apparel］
CD：須藤亮（Mo-Green）　AD：永野有紀（Mo-Green）　D：山本実麗（Mo-Green）
P：小尾淳介　スタイリスト：黒澤充（eight peace）
編集：溝口加奈（Mo-Green）/ 小倉冬美香（Mo-Green）　SB：Mo-Green

106

乗る人すべての安全を、
何よりも大切にすること。
事故のない未来をつくること。
その決意を胸に、私たちは
性能を磨き上げてきました。
クルマが安心であるほど、
人生の愉しさはもっと広がる。
万一のときだけでなく、
安全な運転を支える技術まで。
スバル独自の「総合安全」は、
これからも進化を続けてゆきます。

New SUBARU SAFETY

スバルの総合安全

クルマは、人生を乗せるものだから。
New SUBARU Story

[SUBARUお客様センター] SUBARUコール 0120-052215　受付時間：9:00〜17:00(平日)、土日祝は9:00〜12:00, 13:00〜17:00 ※平日の12:00〜13:00及び土日祝日は 各種インフォメーションサービスのみとなります。
オフィシャルサイトはこちら　www.subaru.jp　スマートフォンからもアクセス http://sp.subaru.jp/

安心と愉しさを。SUBARU

New SUBARU SAFETY　新聞広告
富士重工業 [自動車 Automobiles]
CD：木村年秀　AD：中尾祐輝　D：雨宮正勝／蒔田のどか　P：興村憲彦　CW：高橋慶生
Pr：酒井雅美　フォトプロデューサー：栗原良次　レタッチ：テコノ　A, SB：電通　DF：たき工房

Relaxed & NATURAL　107

ANTIPAST 2016 S / S　カタログ
ANTIPAST［アパレル　Apparel］
AD, D, SB：Yuki Otani　　P：Shin Jinushi（KiKi inc.）　スタイリスト：Ikuko Tanizaki　ヘア＆メイク：IZUTSU（impress+）　モデル：Kirika（jungle）
プリンティングディレクター：Takashi Ochiai（Butter inc）　Special Thanks：rose's roses

HAPPY BROMPTON タブロイド

ミズタニ自転車［国内・輸入品自動車の企画・卸売　Domestic and import bicycle planning / wholesale］
CD：遠藤崇行（Jet State）　AD：久住欣也（Hd LAB）　D：原田諭（Hd LAB）　P：石黒幸誠（go relax E more）
CW：宮崎 真（モノタイプ）　印刷：関西美術印刷　SB：Hd LAB

この冬、
ウィートエールの森へ、
いきませんか？

フクロウノモリ

グランドキリン うららかをる（a）/ 梟の森（b）　ポスター
キリンビール［酒類事業　Beverages］
CD, CW：前田知巳　AD：細川 剛　D：久保有輝 / 楳村秀冬 / 本多恵之 / 清水玲於奈（a）
制作会社：フューチャーテクスト / 博報堂プロダクツ（b）　A, SB：博報堂　DF：ツープラトン

ラシャス シードルナチュラル / ポワレナチュラル　パッケージ
アレグレス［酒・食品輸入卸　Food and beverage import / wholesale］
AD：宇賀神正人　DF, SB：inc.

This Corn
Brand name, ID, packaging　パッケージ
The Snackatere Corp.
［製菓業　Snack producer］

CD, AD, I : Jovan Trkulja
AD, I : Marijana Rot
SB : Peter Gregson Studio

114

STYLE BREAD　ポスター / パンフレット / 名刺
STYLE BREAD［パンの製造・販売業　Bakery］
CD, AD, D, SB：emuni　P：藤原康利

Relaxed & NATURAL　115

Veggyの家　フライヤー / カード
Veggyの家 ［飲食店 Restaurant］
D：野村ソウ　DF：STUDIO WONDER
SB：WONDER CREW

フライヤー

アルマロードコーヒー　フライヤー
アルマロードコーヒー［コーヒーショップ　Coffee shop］
CD：村川マルチノ佑子　AD：羽山潤一
D：西村明洋 / 張 蓓麗婭　SB：デジマグラフ

カード

Relaxed & NATURAL　117

EAT LOCAL KOBE　タブロイド
神戸市経済観光局農政部農水産課〔行政（農水産物プロモーション）；Government〕
CD：AKIND Inc.（岩野 翼）　Logo Design：Ritator（Gustav Granström）　D：柏倉瑛子
Pr：AKIND Inc.（森江朝広）　P：片岡杏子　SB：AKIND Inc.

札幌PARCO　イベント告知ポスター / フライヤー
札幌 PARCO［ファッションビル Shopping complex］
AD, D：野村ソウ　P：内田有美　DF：STUDIO WONDER
SB：WONDER CREW

Relaxed & NATURAL

a day in the BAKESHOP 書籍

グラフィック社 ［出版社　Publishing］
D：藤田康平（Barber）　P：加藤新作　著者：浅本 充（自由が丘ベイクショップ）　SB：グラフィック社

Relaxed & NATURAL.

Every Table　書籍
主婦の友社［出版社 Publishing］
CD：中野桜子　AD, D：吉村 亮（Yoshi-des.）／眞柄花穂（Yoshi-des.）
著者, P：柳川かおり　I：湯浅 望　SB：主婦の友社

アメリカ西海岸 グリーンライフガイド　書籍
大和書房［出版社 Publishing］
D：藤田康平（Barber）　P：芦澤久美子　著者：シャリマ・ドゥ・ラ・テフテフ　SB：大和書房

122

オープンサンドレシピブック EVERYDAY OPENSANDWICH　書籍
誠文堂新光社［出版社　Publishng］
著者：カタネベーカリー / cimai / ARTISAN BOULANGER CUPIDO / 365日 / TARUI BAKERY / Café Lisette /
シニフィアン シニフィエ　D：藤田康平（Barber）　P：松村隆史　SB：誠文堂新光社

BON BON HOME 2015 Autumn & Winter　カタログ
イトーヨーカ堂［インテリアショップ　Home furnishings］
AD：宇賀神正人　P：川口賢典　スタイリング：茂木雅代
フードコーディネート：廣松真理子　エディター：奥原麻衣　SB：inc.

Relaxed & NATURAL　123

Louis Charden Branding / Packaging　ブランディング / パッケージ
Margaryan Group［焼き菓子専門店　Bakery］
AD：Stepan Azaryan　　D：Karen Gevorgyan　　I：Anahit Margaryan　　P, DF, SB：Backbone Branding

California prune recipebook2　ブックレット
ABC Cooking Studio ［料理教室・食品メーカー　Cooking school / food manufacturer］
AD：山城 由　　D：瀬戸えり子　　P：清水奈緒　　CW：高木沙織　　スタイリスト：洲脇佑美
DF, SB：サーモメーター

la cucina italiana UEKI siciliamo　ロゴ / リーフレット / ラベル
la cucina italiana UEKI ［シチリア菓子専門店　Sicilian pastry shop］
CD：久田祐輝　　D：大屋奈々子　　P：月森 文　　DF, SB：オットーデザインラボ

Relaxed & NATURAL. 125

蒼のダイヤ　パッケージ
蒼のダイヤ［エキストラバージンオリーブオイルの製造・加工・販売　Extra virgin olive oil production and sales］
CD, AD, D：秋山カズオ　P：仁田慎吾　CW：野澤幸司　DF, SB：デラックス

Hoegaarden recipebook　ブックレット
ABC Cooking Studio［料理教室・食品メーカー　Cooking school / food manufacturer］
AD, D：五木田裕之　　P：加藤新作　　スタイリスト：洲脇佑美　　DF, SB：サーモメーター

Relaxed & NATURAL

TAGUCHI PRODUCTS Canister Sets　商品プロダクト / DM
TAGUCHI PRODUCTS［インテリア商品販売　Home furnishings］
CD, AD, D：小野圭介　P：鈴木陽介　Pr：田口浩司　DF, SB：ONO BRAND DESIGN

レアシュガープラス　パッケージ
プロスペリティ［食品販売 Food retailer］
AD, D：植松達馬　SB：ADESTY

ボンヌ ファリーヌ　パッケージ / 紙袋
Bread Basket［食品製造販売 Food market］
AD, D, SB：白本由佳

Relaxed &NATURAL. 129

CLASSICS the Small luxury　パッケージ / ハンカチーフ
CLASSICS the Small luxury〔ハンカチーフ専門店　Handkerchief boutique〕
AD, D：八木 彩　A, SB：電通

130

よいことパン　ショッピングバッグ /
ポイントカード・ショップカード / パンフレット
Bread Basket ［ 食品製造販売　Food ］
AD, D, SB：白本由佳

Relaxed & NATURAL.

シシ七十二候（shi-shi shichijuniko）　ショッパー / パッケージ / リーフレット
The Collaboration ［ ライフスタイルブランド　Lifestyle brand ］
AD, D, DF, SB：YANOBI

くまぐすあんぱん　パッケージ / ショップカード
design NAP［デザイン会社　Design firm］
CD, D：藤戸佐千世　D：松村憲志 / 岸良平　I：松村憲志
製造・販売：ララ・ロカレ　SB：design NAP

oisesan　パッケージ
oisesan［アパレル　Apparel］
CD, AD：内田喜基
D：野畑太貴 / 野澤亜紀子
P：福島典昭　DF, SB：cosmos

Relaxed & NATURAL. 133

絵のない絵本　フライヤー
富士見市民文化会館キラリ☆ふじみ　[公立劇場　Public theatre]
AD, D, SB：内川たくや（ウチカワデザイン）

Nostalgic & NEW RETRO

Milwaukee Magazine August 2012 Cover - Best Burgers　雑誌カバー
Milwaukee Magazine ［地域雑誌　City & regional magazine］
AD, SB：Kathryn Lavey　P：Adam Ryan Morris　I：Mary Kate McDevitt

HODOHODO HAIR + MORE　フライヤー / ショップカード / 年賀状
HODOHODO HAIR + MORE［美容室　Hair salon］
AD, D：スミカズキ　DF, SB：KEYDESIGN

time is timeless
いくつになっても。

Man, I love tennis!

No, no, no! Like this! You have to swing more like this!

CLASSIQUE LINE

le coq sportif

le coq sportif CLASSIQUE LINE 2015F/W　ルックブック
ルコックスポルティフ（デサント）［ スポーツアパレル　Sports apparel ］
AD, SB：武田健吾　P：土山大輔（TRON）　A：ACUSYU
スタイリスト：Yoshi Miyamasu（SIGNO）　ヘア＆メイク：塩沢延之（mod's hair）
レタッチ：栗原史（chest nuts）

Chucks
SISTERS
ALL STAR RIBBONCOLLAR MID

Chucks
SISTERS
ALL STAR TWINSISTERS HI

Chucks
SISTERS
ALL STAR SPARKLY OX

Chucks
SISTERS
ALL STAR VEGEFRUS HI

CHUCKS SISTERS 2014FW　ポスター
CONVERSE FOOTWEAR ［シューズブランド　Footwear］
CD, AD：吉田芳洋　　CD：菊池志帆　　D：東 さや香 / 玉川克人　P：OSAMU MATSUO（STUH）
スタイリスト：AYAKA ENDO（TRON）　　ヘアメイク：YOSHIKAZU MIYAMOTO（perle）　DF, SB：ネンデザイン

Chucks
SISTERS
ALL STAR RIBBONSTRIPE HI

Chucks
SISTERS
ALL STAR LEOPARDFUR SLIP-ON

CONVERSE 2015 FW キャンペーン　ポスター
CONVERSE FOOTWEAR［シューズブランド　Footwear］
CD, AD：吉田芳洋　　CD：菊池志帆　　D：東さや香／玉川克人　P：SHINICHI SASAKI（SIGNO）　I：SANNA MANDER（Agent Pekka）　ヘア：YUTAKA KODASHIRO（mod's hair）
メイク：MASAYO TSUDA（mod's hair）　スタイリスト：JUNYA HAYASHIDA（SIGNO）　美術：NORIO YAMAZAKI（JET'S PROJECT）　DF, SB：ネンデザイン

PIG&ROOSTER 2015 SPRING&SUMMER　カタログ
RAD TIMES CO., LTD　［アパレル　Apparel］

CD：須藤 亮（Mo-Green）　AD：永野有紀　（Mo-Green）　D：山本実麗（Mo-Green）　P：酒井 康（P2-7）／小尾淳介（LOOK）／小山幸彦（STUH）＜ITEM＞　プロデューサー：永尾智憲（Mo-Green）
編集：影山直美（Mo-Green）／木村 慶（Mo-Green）　モデル：SATOSHI　SAFFEN／KIRK（ACTIVA）　ヘアメイク：TARO　YOSHIDA　スタイリスト：宇佐美陽平（BE NATURAL）　SB：Mo-Green

ROSEBUD COUPLES Spring 2015　カタログ
ローズバッド ［アパレル Apparel］

CD：須藤 亮（Mo-Green）　AD：永野有紀（Mo-Green）
D：松本敦子（Mo-Green）　P：後藤啓太（モデル）／大志摩 徹（アイテム）
モデル：Federico（AVOCADO）／ Sundberg Naomi（eva management）
ヘアメイク：河村慎也（mod's hair）　スタイリスト：遠藤彩香（TRON）
編集：佐藤香織　SB：Mo-Green

ROSE BUD COUPLES Summer 2015　カタログ
ローズバッド ［アパレル Apparel］

CD：須藤 亮（Mo-Green）　AD：永野有紀（Mo-Green）
D：松本敦子（Mo-Green）　P：高木将也（モデル）／大志摩 徹（アイテム）
モデル：Federico（AVOCADO）／ Sundberg Naomi（eva management）
ヘアメイク：小澤麻衣（mod's hair）　スタイリスト：遠藤彩香（TRON）
SB：Mo-Green

INTIMATE DIARY / NUMERO UNO　シーズンカタログ
INTIMATE DIARY / NUMERO UNO ［アパレル　Apparel］
AD, D, SB：岸 さゆみ　　P：kisimari（W）　　スタイリスト：小沢 宏　　Video grapher：WHO YOU　　ヘアメイク：Jiro for Kilico　　モデル：Justin / Varvara

Nostalgic & **NEW RETRO**　145

ACME FURNITURE BRAND 2016 ORIGINAL CATALOG　カタログ
ACME［家具　Furniture］
CD：須藤亮（Mo-Green）　AD：永野有紀（Mo-Green）　D：山本実麗（Mo-Green）
P：赤尾昌則（white STOUT）＜イメージ＞/ ISSEI（アイテム）　ディレクター：永尾智憲
編集：木村 慶（Mo-Green）/ 阪本 歩（Mo-Green）　スタイリング：ACME FURNITURE　SB：Mo-Green

niko and ... OPTICAL　カタログ
アダストリア
［衣料品・雑貨　Clothing and miscellaneous goods］
D：谷川智則（アダストリアマーケティング部クリエイティブチーム）
SB：アダストリア

Nostalgic & **NEW RETRO**

Drink Me Magazine masthead & cover art 雑誌
Drink Me Magazine 〔酒類雑誌 Wine, beer & spirits publication 〕
D SB Joel Felix

148

OKINAWA：A Journey of Discovery　交通広告（キービジュアル）Web
沖縄県庁 ［地方自治体　Local government］
CD：佐々木美和 / 川村佳央　ディレクター：中西圭吾 / 見學達樹　プロデューサー：稲瀬崇行 / 篠原徹行　AD：下川大助　D：大山晃弘 / 井上寛教　プログラマー：根岸良樹 / 松石登界
P：初沢亜利 / 島袋常貴　シネマトグラファー：新垣憲之 / 中山大志　ロケーションコーディネーター：上里忠司　フォトレタッチャー：中島隆太　ロゴアニメーション：安田吉宏
ムービー：STAY GOLD　プロダクション：MASKMAN inc. / AOI Pro.　A：電通　DF, SB：highlights inc.

OKINAWA：the Secret Is out　交通広告（キービジュアル）Web
沖縄県庁 ［地方自治体　Local government］
CD：佐々木美和　アカウントエグゼクティブ：前田弓子　CW：嶋野裕介 / 柴田修志　ディレクター：中西圭吾 / 山崎涼子　プロジェクトマネージャー：小林徹哉　AD：下川大助
D：大山晃弘 / 井上恵 / 鈴木康弘 / 戸上淳司　プログラマー：根岸良樹 / 八木原智之　ムービー：STAY GOLD　プロダクション：MASKMAN inc. / トイズ　A：電通 / 電通沖縄　DF, SB：highlights inc.

RAGEBLUE BOYS CURRY TEE　ポスター / Tシャツ
アダストリア［衣料品・雑貨等の企画・製造・販売　Planning, manufacturing and sales of clothing and miscellaneous goods］
AD, D, SB：押見 健太郎

シブヤビール　商品ラベル
LD&K ［ビール製造・販売　Brewers］
CD：ミズノナオト　D：田村 亮　SB：LD&K

CASA de BAR　パッケージ
マルハニチロ［水産・食品　Fishery / foods］
SB：マルハニチロ

ゴーフレール　パッケージ / パンフレット
レスポワール ［洋菓子製造販売業　Confectionery］
SB：神戸凮月堂

152

シュウウエムラ　50周年タブロイド
日本ロレアル
［化粧品・香水・ヘアケア製品などの輸出入・マーケティング
Import / export and marketing of cosmetics, perfumes, and hair care products］
AD：宮本理希　D：工藤真由美　SB：ダイナマイト・ブラザーズ・シンジケート

KAORI WAKAMATSU 2015　カレンダー
COMMUNICATION MANIA ［雑貨店　Novelty shop］
AD, D, SB：emuni　ARTWORK：ワカマツカオリ

CAFE OHZAN 伊勢丹新宿限定クリスマスキューブラスク　パッケージ
櫻山 〔 カフェ、パン・菓子製造販売 Café / bakery 〕
AD：倉波由起子　I：白井 匠　プロデューサー：Bohemian DeDe
DF, SB：サーモメーター

Nostalgic & NEW RETRO　155

ENTERRO DA GATA 2012 Promotional Poster　ポスター
AAUM - Associação Académica da Universidade do Minho ［学生協会　Student association］
AD：Leandro Veloso　D：Rui Malheiro　DF, SB：gen design studio

The TINNED　パッケージ
マルハニチロ
［水産・食品　Fishery / foods］
SB：マルハニチロ

& ROLL　グリーティングカード
& ROLL［美容室　Hair salon］
AD, D：秋元勇太　DF, SB：VIVIFAI

Nostalgic & NEW RETRO

Void Magazine Cover Design　雑誌
Void Media［ライフスタイル・メディア・カンパニー　Lifestyle Media Company］
CD, SB：Tye Wallace　AD：Kingsley Spencer　P：Logan Bowles
I：Shauna Lynn Panczyszyn

Eau Fleur et Chocolat　パッケージ
エイボン・プロダクツ［化粧品製造　Cosmetics］
AD, D：秋元葉子　DF, SB：VIVIFAI

158

アドバンスト・スタイル そのファッションが、人生　ポスター
アルバトロス・フィルム ［映画配給会社　Film distribution］
AD, SB：大島依提亜

LE BRASSUS Hills Store Opening Event Identity
オープニングイベントアイデンティティ（バッジ / ネオン）
Audemars Piguet via MA3 agency
【スイス製高級腕時計 Swiss luxury watch】
D：Violaine Orsoni / Jeremy Schnelder　I：Jeremy Schnelder
A：MA3 agency new york　DF, SB：Violaine / Jeremy

The Derby フリスビー / パッケージ
The Derby 【ヘアサロン Hair salon】
プロデュース：荒内健治 _SpinCollectif TOKYO
SB：The Derby

160

Nostalgic & NEW RETRO

LE BAIGNEUR（ル・ベヌール）　パッケージ / トートバッグ
LE BAIGNEUR［化粧品製造　Cosmetics］
CD：FABIEN MEAUDRE　AD：Léa Chapon et Mytil Ducomet　DF：Atelier Müesli　SB：イー・エフ・インターナショナル

World of Foote Event Poster　イベントポスター
One World Foundation, Players by the Sea.
［文化イベント　Cultural event］
Executive Creative Director: Jorge Brunet-Garcia　CD：Jefferson Rall
AD, D：Kedgar Volta　I：Shauna Lynn Panczyszyn　A, SB：Brunet-Garcia Advertising

kokochi　DM
kokochi［美容室　Hair salon］
AD, D, DF, SB：サーモメーター

Nostalgic & NEW RETRO　163

IL BACARO ALMA　ポスター / メニュー / ショップカード
コンセプション [飲食店　Restaurant]
AD：高谷 廉　D, SB：AD&D　P：原淵將嘉 / 梅原祐一　I：西田真魚

Veggyの家　5周年記念ポスター
Veggyの家 ［飲食店　Restaurant］
D：野村ソウ　DF：STUDIO WONDER　SB：WONDER CREW

AKOMEYA TOKYO　ギフトラッピング
サザビーリーグ　AKOMEYA　TOKYO
［ライフスタイルショップ　Lifestyle shop］
SB：サザビーリーグ

珈琲羊羹　パッケージ
アポロコーヒーワークス［コーヒーショップ　Coffee shop］
AD：宮下ヨシヲ　D：小粥絵梨菜　I：熊谷隼人　DF, SB：サイフォン・グラフィカ

カリーと古民藝　展示DM
SML［器屋　Tableware］
AD, D, SB：サーモメーター

やきいも日和　パッケージ
やきいも日和［飲食店　Restaurant］
D：チョウハシトオル　SB：やきいも日和

Nostalgic & NEW RETRO　167

KIRINJI EXTRA11　CDジャケット
ユニバーサル ミュージック［レコード会社　Record company］
AD, SB：大島依提亜　　P：加藤新作　　スタイリスト：丸山佑香

168

槙原敬之 Lovable People　CDジャケット
WORDS & MUSIC［音楽事務所　Music office］
CD：五味桃子（WORDS & MUSIC）　AD, D, SB：emuni
P：藤原康利　TITLE DESIGN, ARTWORK：金子 裕亮（DAMKY SIGNS）
スタイリスト：中田 愛（Ant）　ヘアメイク：晋平（abbey2）

KIRINJI presents SIXTH x SIX　CDジャケット
ユニバーサル ミュージック［レコード会社　Record Company］
AD, D, SB：大島依提亜

Nostalgic & NEW RETRO

ニシノユキヒコの恋と冒険　DVD / ポスター
関西テレビ放送（DVD）/ 東宝（ポスター）
［ テレビ放送 / 映画製作・配給　TV broadcasting, film production / distribution ］
AD, SB：大島依提亜　©2014「ニシノユキヒコの恋と冒険」製作委員会

YUI FIND ME YUI Visual Best
DVD・ブルーレイ
Sony Music Labels
［音楽・映像ソフトの企画制作
Audio-visual software production］
AD, D：いのうえよしひろ　DF, SB：ジョットグラフィカ

ポスター

Nostalgic & NEW RETRO　171

のんびりイビサ　書籍
スペースシャワーブックス［出版社 Publishing］
D：藤田康平（Barber）　著者：カルロス矢吹　SB：スペースシャワーブックス

New Kyoto 京都おしゃれローカルガイド　書籍
スペースシャワーブックス［出版社 Publishing］
D：藤田康平（Barber）　P：JJ　著者：多屋澄礼　SB：スペースシャワーブックス

172

SHOP image
LOGO

no. 01 Abarrotes Delirio
[飲食 Food and beverage] Mexico

CL：Abarrotes Delirio　CD：Rafael Prieto　AD：Eduardo Hernández　D：Bernardo Domínguez　CW：Raúl Salazar　P, DF, SB：Savvy Studio

no. 02 THE LOCAL COFFEE STAND

［コーヒースタンド　Coffee stand］　Japan

東京都渋谷区渋谷 2-10-15

ステッカー

CL：THE LOCAL　　D：竹内 剛宏　　DF, SB：Good Coffee

no.03 Villa de Patos
［飲食 Food and beverage］ Mexico

CL：Villa de Patos　　CD：Rafael Prieto　　AD, D：Eduardo Hernández　　P：Alejandro Cartagena　　I：Violeta Hernández　　CW：Raúl Salazar　　DF, SB：Savvy Studio

no.04 ROMEA Chrcutería Local

[飲食店 / 食品、ワイン＆チーズ店　Restaurant / food, wine & cheese store]　Mexico

CL：ROMEA Chrcutería Local　　CD, AD, D, P, I：Daniel Barba López　　P：Alicia Viridiana Espinoza / Moises Salcido　　DF, SB：MONOTYPO Studio

no. 05 VERVE COFFEE ROASTERS
[コーヒーショップ　Coffee shop]　Japan

東京都渋谷区千駄ヶ谷 5-24-55
NEWoMan SHINJUKU 2F エキソト

CL, CD, AD, D：VERVE COFFEE ROASTERS　I：マシュー・アレン　SB：CPCenter

ステッカー

SHOP image 181

▶ VERVE COFFEE ROASTERS

"...OW COFFEE
...E LIKE THAT."
...AN. IT DOES.

YOU WANT
AMAZING COFFEES,
THEY HAVE
AMAZING COFFEES.
LET'S DO THIS!

no. 06 El Camino Foodtruck

［フードトラック Food truck］ Mexico

CL : El Camino　　CD : Rafael Prieto / Raúl Salazar　　AD : Eduardo Hernández　　D : Ricardo Ojeda　　P : Alejandro Cartagena　　DF, SB : Savvy Studio

SHOP image 185

no.07 Charcuterie Galibier　シャルキュトリーガリビエ

[ハム・ソーセージ・パテを中心とした加工肉の製造・販売 Charcuterie]　Japan

石川県能美市徳山町ヤ55-1

CL：シャルキュトリーガリビエ　AD：野坂幸平　D：鈴木和恵／岡本千春／吉田竜輔／木谷香　P：杉浦康之　DF, SB：ヴォイス

Rebie
Made in Ishikawa

「Re（再び）」+「Gibier（ジビエ）」=「Rebie（リビエ）」

Lineup of Rebie

Sausage　　　Bacon

Jerky　　　Terrine

How to make ordinary sausage better

Sauté　　Boil

SHOP image

no.08 foodscape!
[飲食業 Restaurant] Japan

大阪府大阪市福島区福島 1-4-32

CL：エルワールド　D：赤井佑輔　I：CHALKBOY（店内サイン）　Pr：堀田裕介　DF, SB：paragram

SHOP image 189

no. 09 100本のスプーン

［ファミリーレストラン Family restaurant］ Japan

東京都世田谷区玉川 1-14-1
二子玉川ライズ S.C. テラスマーケット 2F

CD：Smiles creative div.　P：太田拓実／村山玄子　I：大森智哉　CL, SB：スマイルズ

メインビジュアル

SHOP image 191

no.10 ONOMICHI U2

[複合施設 Multi-use facility] Japan

広島県尾道市西御所町 5-11

ラッピングペーパー

CL：ディスカバーリンクせとうち　AD：柿木原政広　AD, D：河村まゆみ　DF, SB：10

192

SHOP image 193

no. 11 THE ROASTERS & THE STAND
［コーヒー店　Coffee sellers］　Japan

和歌山県和歌山市大河内 547-6

CL：RAPYARD　　AD, D, I, SB：emuni

194

no. 12 | GANORI

［飲食店 / 小売　Restaurant / retail］　Japan

東京都世田谷区世田谷 2-22-2
サークルビル 102

CL：ガノリ　CD：草彅洋平（東京ピストル）　I：岡本 亮 / 植木 駿　D, SB：東京ピストル

SHOP image　195

no. 13 やまねフランス

[焼き菓子店　Bake shop]　Japan

東京都世田谷区池尻 4-39-6
北嶋ビル1F

CL, SB：やまねフランス　AD：岩崎悦子　P：中島洋介　CW：山根愛香

196

no. 14　to_dining & daily goodthings
[飲食店　Restaurant]　Japan

茨城県水戸市泉町2-2-44

ショップカード

CL：to_dining & daily goodthings　AD, D：笹目亮太郎　D：助川智美　SB：TRUNK

SHOP image　197

no.15 Dandelion Chocolate

ダンデライオン・チョコレート　ファクトリー＆カフェ蔵前

［チョコレート製造業　Craft chocolate makers］　Japan

東京都台東区蔵前 4-14-6

CL：ダンデライオン・チョコレート・ジャパン（日本）／ Dandelion Chocolate（サンフランシスコ（SF））　AD：堀渕伸治（ティー・グラフィックス）〈日本版ショップツール〉
SB：ダンデライオン・チョコレート・ジャパン　CD：Dandelion Creative Team in Collaboration with Caleb Owen Eventt&Ryan Rhodes（チョコレートバーラベル）
／ Dandelion Creative Team in Collaboration with Anthony Ryan（チョコレートバー包装）／ Dandelion Creative Team in Collaboration with Yvonne Mouser（チョコレートバーコレクションボックス）
／ Dandelion Creative Team in Collaboration with Robert van Horne（ディスプレイサイン〈大＆小〉）　AD：Dandelion Creative Team（SF版ツール）

ギフトラッピング（SF）

ギフトカード（SF）

コレクションボックス（SF）

SHOP image 199

no. 16

DAVID OTTO JUICE & KIPPY'S COCO-CREAM

デービッド オットー ジュース & キッピーズココクリーム

［コールドプレスジュースショップ & アイスクリームショップ　Cold Pressed Juice Shop & Ice Cream Shop］　Japan

東京都渋谷区千駄ヶ谷 2-6-3

CL, SB：サザビーリーグ　リトルリーグカンパニー

200

ポスター

ショップカード

ノベルティ1
ステッカーシート

インビテーション

ノベルティ2
トートバッグ

SHOP image 201

no.17 Smørrebrød kitchen nakanoshima スモーブローキッチン ナカノシマ

［飲食店 Restaurant］ Japan　　大阪府大阪市北区中之島1-2-10 中之島図書館2F

CL：エルワールド　AD, D：赤井佑輔　Pr：堀田裕介　DF, SB：paragram

202

no. 18 The Girl and the Bull

[飲食店 Food / Beverage / Restaurant] — Philippine

CL：The Girl and the Bull　CD：Deane Miguel　AD：Lester Cruz　D：Tintin Lontoc / Kookie Santos　SB：Serious Studio

no.19 パンごはん ゆいまーる

［カフェ・食堂 Café / dining］ Japan

大阪府柏原市国分西 1-1-47

ランチョンマット

CL：パンごはん　ゆいまーる　　CD：久田祐輝　　AD, D：市野孝洋　　I：藤本紗由美　　DF, SB：オットーデザインラボ

no. 20 ランプが灯るオステリア ミートラボ
[飲食店 Restaurant] Japan

東京都目黒区青葉台1-17-2
青葉台117ビル2F

ポスター

CL：ランプが灯るオステリア ミートラボ　CD：玉村浩一　AD, D：中市 哲　店舗内装：ネジアーキテクツ　DF, SB：ライツデザイン

SHOP image　205

no. 21 french panda
[飲食店 Restaurant] Japan

北海道札幌市中央区南3西3-3
G-DINING B1F

CL：french panda　CD, AD, D, DF, SB：COMMUNE　P：古瀬 桂　インテリアデザイン：マンゲキョウ

206

no. 22 HAIR DESIGN YURA for MEN

[美容院 Hair salon] Japan

群馬県太田市由良町 189-2

CL：HAIR DESIGN YURA for MEN　　CD：玉村浩一　　AD, D：中市 哲　　サインペイント：DAMKY SIGNS 金子裕亮　　DF, SB：ライツデザイン

SHOP image　207

no. 23　Salon Hanano

［美容院　Hair salon］　Japan

東京都港区南青山 1-3-24

CL：Salon Hanano　D, I, SB：naohiga

208

1. KARUIZAWA（ISETAN 期間限定イベント）　THEATRE PRODUCTS［ファッションブランド　Fashion brand］　AD, D, SB：日本由佳
2. kikori　中川町役場［役場　Town hall］　CD：寺島賢幸　AD, D：森川瞬　CW：仲吉蘭　DF, SB：寺島デザイン制作室
3. 白山ジオトレイル　白山ジオトレイル実行委員会［ジオトレイル（山野を走る競技）イベントの運営　Geotrail (long trail footrace) event organizers］
　　AD：財部裕貴　D：石本迪輝　DF, SB：ヴォイス
4. wine & dish Pin　wine & dish Pin［飲食店　Restaurant］　CD：笹森義人　AD, D：森川瞬　DF, SB：寺島デザイン制作室
5. SHARE PARK　シェアカンパニー［不動産　Real estate］　AD, D：柴田ユウスケ　DF, SB：soda design

1. **With PLANET**　With PLANET［造園業　Landscape gardening］　AD, D：笹目亮太郎　SB：TRUNK
2. **SU-BEE**　サビー［飲食店経営・店舗プロデュース　Restaurant operators / producers］　AD, D：鈴木和恵　DF, SB：ヴォイス
3. **NOMADOï**　ヤマニ［アパレル製造販売　Apparel］　CD：島田 明　AD：久住欣也　D：中平恵理　DF, SB：Hd LAB
4. **ACTUS SOHOLM CAFÉ**　アクタス［インテリア輸入・アパレル製造販売・飲食業　Import interior / Apparel / Restaurant］　AD：久住欣也　D, DF, SB：Hd LAB
5. **レウィマーケット**　レウィマーケット［雑貨・インテリア　Home furnishings］　CD：玉村 浩一　AD, D：中市 哲　DF, SB：ライツデザイン
6. **Grenoble**　Grenoble［焼き菓子専門店　Bakery］　D：山本洋介　SB：MOUNTAIN BOOK DESIGN

1. natalie　Yocouchi&Co.［美容業　Hair and beauty］　AD, D: 笹目亮太郎　D: 助川智美　SB: TRUNK
2. メガネコーヒー　メガネコーヒー［カフェ　Café］　CD: 竹日 渉　SB: メガネコーヒー
3. FujiCOCO　ブラウンシュガーファースト［食品　Food］　AD, D: 柴田ユウスケ　DF, SB: soda design
4. TAILORED COFFEE　TAILORED COFFEE［コーヒー豆販売　Coffee beans］　D: 野村ソウ　DF: STUDIO WONDER　SB: WONDER CREW
5, 6. ビストロ シロ　ポトマック［飲食業　Restaurant］　CD: 森野圭太　AD: 吉川裕二　D: 阿部真由子　SB: ポトマック

1. HITOSAJI　ブリス・デリ＆マーケティング［飲食店 Restaurant］　D:山本洋介　SB:MOUNTAIN BOOK DESIGN
2. ink stand by kakimori　カキモリ［文具店 Stationery store］　AD, D: 関 宙明（ミスター・ユニバース）　DF:ミスターコンバース　SB:カキモリ
3. Beek Life Style　BEEK［編集・デザイン・メディア　Editing / Design / Media］　CD:土屋 誠　I:土屋恭子　DF, SB:BEEK DESIGN
4. ph hut atelier　phono［輸入ヴィンテージ家具の販売・レストア　Import vintage furniture sales / restoration］　AD, D:笹目亮太郎　SB:TRUNK
5. E-girls COLORFUL DIARY（写真集）　幻冬舎［出版社 Publishing］　AD:前川朋徳　I:兎村彩野　DF, SB:Hd LAB
6. ACTUS KIDS「gift and Dream FURNITURE 2015」　アクタス［インテリア輸入・アパレル製造販売・飲食業　Import interior / Apparel / Restaurant］
 AD:久住欣也　D:前川朋徳／高橋淳一　I:兎村彩野　DF, SB:Hd LAB.

1. THE UNION PARK　　WELL JAPAN inc.［アミューズメントパーク　Amusement park］　　AD, SB：emuni　D, ARTWORK：金子裕亮（DAMKY SIGNS）
2. A CUP OF COFFEE　　WELL JAPAN inc.［アミューズメントパーク　Amusement park］　　AD, SB：emuni　D, ARTWORK：金子裕亮（DAMKY SIGNS）
3. Shirai Keet　　シライミュージック［楽器販売店・製造　Musical instruments］　　AD：宮下ヨシヲ　D：小粥絵梨菜　DF, SB：サイフォン・グラフィカ
4. Mono Deco Labo.　　Mono Deco Labo.［レーベル　Record label］　　AD, D, SB：清水真介（homesickdesign）　　SB：homesickdesign
5. BARBERS generation　　Ninth［理容室専門に特化した店舗設計のPRサイト　PR website for store designers specialized in hair salons］　　CD：久田祐輝　AD, D：市野孝洋　DF, SB：オットーデザインラボ
6. MAKIHARA NORIYUKI SYMPHONY ORCHESTRA CONCERT "cELEBRATION 2015"〜Starry Nights〜
　　WORDS & MUSIC［音楽事務所　Music office］　　CD：五味桃子（WORDS & MUSIC）　　AD, D, SB：emuni

1. **zizi**　木村硝子店［ガラス製造　Glassware］　AD, D：田中竜介　　DF, SB：ノーチラス号 / ドラフト
2. **the 3rd Burger**　ユナイテッド＆コレクティブ［飲食店の経営　Restaurant management］　SB：ユナイテッド＆コレクティブ
3. **Brown Bunny**　ワールド［アパレル　Apparel］　AD：田中竜介　D：杉山耕太　DF, SB：ノーチラス号 / ドラフト
4. **Butter Butler**　シュクレイ［和・洋菓子の企画、販売　Confectionery］
　CD：梅田武志（ザッツ・オールライト）　AD, D：河西達也（ザッツ・オールライト）　I：NUTS ART WORKS　SB：ザッツ・オールライト
5. **バルマルシェ コダマ**　バルマルシェ コダマ［バル Bar］　SB：コダマ
6. **TOKYO COWBOY**　TOKYO COWBOY［和牛専門精肉店　Butcher specialized in Japanese beef］　SB：JNYコーポレーション

1. ホステル ザブトン　ホステル ザブトン［ホステル Hotel］　CD：玉村浩一　AD, D：中市 哲　DF, SB：ライツデザイン
2. HAPPY SURPRISE IN OKINAWA　沖縄県庁［地方自治体 Local government］　CD：佐々木美和　アカウントエグゼクティブ：前田弓子　CW：嶋野裕介／柴田修志
ディレクター：中西圭吾／山崎涼子　プロジェクトマネージャー：小林徹哉　AD：下川大助　D：大山晃弘／井上恵／鈴木康弘／戸上淳司　プロダクション：MASKMAN inc.／トイズ
A：電通／電通沖縄　DF, SB：highlights inc.
3. 神戸電鉄（採用パンフレット）　神戸電鉄［サービス業 Service industry］　AD, D：矢野恵司　SB：ケセラセラ
4. エイジングミート＆デリカテッセン 旬熟成　エイジングミート＆デリカテッセン 旬熟成［飲食店 Restaurant］　CD：玉村浩一　AD, D：中市 哲　DF, SB：ライツデザイン

INDEX

SUBMITTER INDEX
作品提供者索引

あ

赤井佑輔 (paragram) ... 039

AKIND Inc. ... 118

旭化成ホームズ ... 098, 099, 100

アダストリア .. 146, 147

ADESTY .. 038, 047, 129

ANSWR ... 030

イー・エフ・インターナショナル 162

inc .. 112, 123

VIVIFAI .. 157, 158

ヴォイス ... 088, 186, 187, 210, 211

内川たくや (ウチカワデザイン) 134

ULTRA HEAVY ... 070, 071

Hd LAB .. 022, 023, 024, 109, 211, 213

AD&D ... 043, 086, 164

emuni 012, 013, 052, 054, 058, 059, 060, 061
 066, 067, 114, 115, 154, 168, 169, 194, 214

LD&K ... 151

大島依提亜 ... 062, 159, 168, 169, 170

押見 健太郎 ... 026, 042, 097, 150, 151

オットーデザインラボ ... 125, 204, 214

ONO BRAND DESIGN .. 065, 128

か

カキモリ ... 213

KIGI ... 094, 095

KEYDESIGN	137
岸 さゆみ	145
Good Coffee	176, 177
グラフィック社	120, 121
GRAPHITICA	072
ケセラセラ	216
神戸風月堂	152
広和	016
ゴールドウイン	096
cosmos	133
コダマ	215
COMMUNE	044, 093, 206
コロンビアスポーツウェアジャパン	102, 103
コンコルド・グラフィック	095
CPCenter	180, 181, 182, 183

さ

サイフォン・グラフィカ	166, 214
サザビーリーグ	166, 167
サザビーリーグ リトルリーグカンパニー	200, 201
The Derby	160
ザッツ・オールライト	215
サーモメーター	083, 125, 127, 155, 163, 167
J.C.SPARK	010, 011
JNY コーポレーション	215

主婦の友社	122
小学館	105
JOCKRIC	027
ジョットグラフィカ	078, 079, 171
白本由佳	080, 129, 131, 210
SPRING VALLEY BREWERY	065
スペースシャワーブックス	172
スマイルズ	190, 191
誠文堂新光社	123
セメントプロデュースデザイン	085, 087
soda design	030 031, 049, 210, 212

た

ダイナマイト・ブラザーズ・シンジケート	153
大和書房	122, 123
武田健吾	138, 139
TABI LABO	073
ダンデライオン・チョコレート・ジャパン	198, 199
手紙社	090
design NAP	133
デジマグラフ	117
寺島デザイン制作室	014, 210
デラックス	126
10	050, 051, 192, 193
電通	053, 064, 081, 093, 107, 130

219

東京ピストル .. 195
TRUNK .. 015, 197, 211, 212, 213
トロープ ... 084

な

naohiga ... 208, 209
中川政七商店 ... 063
ナガタデザイン ... 008, 009
ナカムラグラフ 028, 029, 101, 104, 105
ネンデザイン 020, 060, 061, 140, 141, 142
ノーチラス号 / ドラフト ... 215

は

highlights inc. .. 149, 216
博報堂 .. 062, 063, 110, 111
BAM .. 078, 079
林 洋介 ... 092
paragram ... 188, 189, 202
balance inc. ... 018, 019
パル ... 027
PANKEY ... 021, 101
BEEK DESIGN .. 213
POOL inc. ... 076, 077
ポトマック .. 212
homesickdesign .. 214

SUBMITTER INDEX

ま
マイナビ出版 ... 068, 069
MOUNTAIN BOOK DESIGN 091, 211, 213
マルハニチロ ... 151, 157
箕面ビール .. 067
メガネコーヒー ... 212
Mo-Green 025, 028, 029, 032, 033, 045, 106, 143, 144, 146, 147

や
やきいも日和 .. 167
YANOBI ... 132
やまねフランス ... 196
Yuki Otani .. 108, 109
ユナイテッド & コレクティブ 215

ら
ライツデザイン 205, 207, 211, 216
ライノ ... 034, 035
ルームコンポジット .. 048
れもんらいふ 056, 057, 074, 075

わ
WONDER CREW 036, 037, 116, 117, 119, 165, 212

Anagrama .. 040, 041, 042
Backbone Branding .. 124

Brunet-Garcia Advertising 163
Futura .. 082
gen design studio ... 156
Joel Felix .. 148
Judit Besze .. 082
Kathryn Lavey .. 136
MONOTYPO Studio ... 179
Oddds .. 046
Peter Gregson Studio ... 113
Savvy Studio 174, 175, 178, 184, 185
Serious Studio ... 203
Tye Wallace .. 158
Violaine / Jeremy 160, 161

221

サードウェーブ・デザイン
Third Wave Design

2016年8月19日　初版第1刷発行

Cover Art Direction & Design
emuni

Cover Art Work
金子祐亮（DAMKY signs）

Cover Photographer
西郡トモノ　Tomono Nishigori

Art Director
松村大輔　Daisuke Matsumura

Art Director & Designer
柴 亜季子　Akiko Shiba

Designer
池田 寛　Hiroshi Ikeda

Photographer
藤本邦治　Kuniharu Fujimoto
藤牧徹也　Tetsuya Fujimaki
沖本 明　Akira Okimoto

Translator
パメラミキ　Pamela Miki

Editor & Coordinator
数野由香子　Yukako Kazuno
鈴木久美子　Kumiko Suzuki
高木沙織　Saori Takagi
撫本美樹　Miki Nademoto

Editor
諸隈宏明　Hiroaki Morokuma

発行元　株式会社 パイ インターナショナル
〒170 - 0005 東京都豊島区南大塚 2-32-4
TEL 03-3944-3981　FAX 03-5395-4830
sales@pie.co.jp

PIE International Inc.
2-32-4 Minami-Otsuka, Toshima-ku, Tokyo 170-0005 JAPAN
sales@pie.co.jp

編集・制作　PIE BOOKS
印刷・製本　サンニチ印刷株式会社

© 2016 PIE International
ISBN 978-4-7562-4805-3 C3070 Printed in Japan

本書の収録内容の無断転載・複写・複製等を禁じます。
ご注文、乱丁・落丁本の交換等に関するお問い合わせは、小社営業部までご連絡ください。

PIE International Collection

New Retro
レトロスタイルがあたらしいロゴ&グラフィックス

Pages: 256 (Full Color) ¥3,900 + Tax ISBN : 978-4-7562-4790-2

スタイリッシュであたらしい、レトロスタイルの数々!古き良き時代のグラフィックデザインや印刷・加工技術にインスパイアされた現代の作品を集めました。ロゴに始まり、パッケージ・装幀・ショップインテリア&ツールなど、「レトロ」はこんなにも使える!そんなアイディアと発見をこの1冊でどうぞ。

※ This title is available only in Japan.

Small Shop Graphics in Japan: 87 Inspirational Design Idea
小さなお店のショップイメージグラフィックス

Pages: 176 (Full Color) ¥3,900 + Tax ISBN: 978-4-7562-4681-3

ここ数年、全国的に都市・郊外を問わず、小規模経営ながらデザインにこだわったショップが多く目につきます。本書では、衣・食・住・美の個性的でおしゃれなショップの店舗デザインとグラフィックツール・プロモーションツール・ショップの簡単な見取り図を掲載します。グラフィックデザイナーや素敵なデザインのショップを開業してみたいと思っている方々の参考になる1冊です。

In Japan these days, shops that are small in size but big on design are on the rise. Small Shop Graphics in Japan presents both the interior and exterior designs of a variety of small cafes, bars, restaurants and specialty shops. With simple floor plans and key design elements for each included, this title is a great reference for interior/graphic designers and shop owners alike.

PARIS: Beautiful Designs on the Street Corner
デザインが素敵な、パリのショップ

Pages: 160 (Full Color) ¥3,800 + Tax ISBN : 978-4-7562-4554-0

こだわりのショコラティエや先端を行くファッションブランドまで、食やモードの流行が生まれるパリ。パリのショップは、インテリアやグラフィックなどトータルな世界観でブランドの魅力を作り出しています。本書では、幅広いジャンルのショップから、デザインが素敵なお店を厳選して紹介します。これからお店をオープンしたいと思っているオーナーさんや、ショップデザインに関わる方々に参考にしていただける書籍です。

This is the brand-new title which follows PIE's successful projects of 'Shop Image Graphics' series. Every 2 or 4 pages are consist of Shop Data and plenty of photos introducing Shop Interior, Display Ideas, Brand Logos and Package Designs. This title can be a good reference book for graphic designers and shop owners to know the trends in Paris. And in addition, those who plan to visit Paris and look for something special may also like this title.

London: Beautiful Designs on the Street Corner
デザインが素敵な、ロンドンのショップ

Pages: 224 (Full Color) ¥3,800 + Tax ISBN: 978-4-7562-4786-5

様々な人種が交わるロンドンだからこそ生まれる、新しいカルチャー。そんなロンドンならではの刺激的でユニークなデザインのショップを紹介します。地下鉄の駅をそのままインテリアにしたカフェや、洗練されたライフスタイルを提案するオーガニックブランドなど、食品・生活・ファッション・サービス業のカテゴリーに分けて紹介します。他の都市にはない、オリジナリティ溢れるショップが満載の書籍です。

London has always been a cultural melting pot in Europe and has long been regarded as the epicenter of new trends. This book introduces a curated selection of approximately 63 shops from the cosmopolitan city of London grouped into 3 chapters: Food, Life and Service. Each shop's distinctive ideas for branding & interior design offer a new take on high-impact design for graphic designers, shop owners and anyone seeking fresh inspiration. As with PIE's previous title, 'PARIS: Beautiful Designs on the Street Corner,' travellers, too, will surely appreciate this stylish, up-to-date city guide to London.

Less Colors, More Impact: Effective Designs with Limited Colors
単色×単色のデザイン

Pages: 224 (Full Color) ¥3,800 + Tax ISBN : 978-4-7562-4589-2

単色デザインの可能性が広がる!アイデアソースを凝縮。「単色×単色」のデザインは、シンプルでインパクトのある表現としてだけでなく、アナログ手法やレトロ印刷のブームもあり、広告デザインに多く用いられています。「2色」や「3色」、「3色+α(箔押しなどの特殊印刷)」でデザインされた、4色印刷を超えるインパクトのあるポスターやフライヤー・パンフレット・パッケージ・装丁など国内、海外の広告作品を紹介します。

Using less colors on a graphic design brings an big impact. This title showcases many examples with simple colorings from Japan and the world. Each work is accompanied by actual color tips with PANTONE or DIC numbers.

Look at Me: Eye-catching and Creative Advertising Designs
思わず目を引く広告デザイン

Pages: 256 (Full Color) ¥3,800 + Tax ISBN: 978-4-7562-4568-7

じっくり見たくなる! 記憶に残る! 効果の高い広告が集結。広告はまず、消費者の目に止まることが重要です。自社商品の紹介や、イベント告知の広告をうつならば、まずは消費者に見て興味を持ってもらい、そのうえで記憶に強く印象付けなければなりません。本書では、見る人の心をグッとつかむような広告作品を一同に紹介します。

The most important aspect for advertisement is to capture audience attention. When you are trying to promote a product or service behind the advertisement, the first thing you should do with the design is to be creative to attract the viewer, and then to interest them enough to see the message behind the graphic. In this title, ingenious and eye-catching advertisement works stringently selected are included. They may make the designers think twice and inspire them with their creativity and clever ideas of presenting particular products or service.

Eye-Catching Composition and Layout
一目で伝わる構図とレイアウト

Pages: 336 (304 in color) ¥3,800 + Tax ISBN: 978-4-7562-4476-5

すぐれた「1枚もの」チラシのレイアウト実例集! カクハン写真をメインで使う、キリヌキ写真を複数使う、イラストを使う、素材を使わず文字で見せる…。さまざまな制作条件に合わせて参考にできる便利な素材別実例集です!

Good page layout or page composition comes from the process of placing and arranging and rearranging text and graphics on the page. A good composition is one that is not only pleasing to look at but also effectively conveys the message of the text and graphics to the intended audience. This title is a collection of stunning flyer designs that will be great examples for designers to create a successful layout design. The contents are classified by materials so that designers can arrange the graphics accommodating to individual needs and conditions.

Typography by Design Maestros
匠の文字とデザイン

Pages: 160 (Full Color) ¥3,800 + Tax ISBN: 978-4-7562-4540-3

広告・パンフレット・エディトリアル・パッケージの文字とデザイン特集。文字はデザインにおいて欠かせない要素のひとつです。本書では文字の匠(デザイナー)への取材を行い、作品の要となる文字デザインのコツを探ります。さらにポイントとなる箇所を原寸大で掲載、フォントや級数・字詰め情報などの詳細データとともに解説します。

Typography in graphic design can strongly affect how people react to a document. This title is a collection of cool Japanese typographic designs by selected professional graphic designers. Readers can learn choice of typefaces, kerning, leading, bullets and formatting from the works, all of which are critical for graphic design. Very useful book for not only entry-level designers and students but also for mid-career designers to take a look back over their designs.

PIE International Collection

Branding, Revealed: ays to Build a Stronger Brand Image
スタイル別ブランディングデザイン

Pages: 344 (Full Color) ¥5,800 + Tax ISBN: 978-4-7562-4752-0

消費者のライフスタイルに合わせたマーケットセグメントがなされたブランディングの実例を7つのカテゴリーに分けて紹介しています。コンセプト作りから、ロゴマーク、様々なグラフィックツールそして店舗デザインまで、ブランドはいかにして作られていくのか、186にも及ぶ最新の実例を一挙に紹介します

Building a brand is pointless unless you target the right audience. This title introduces ways to create a brand image to target the right group of people so you can eventually monetize your brand. Various items such as logos, colors, sales promotion tools and advertisements—all of which make up the brand—are showcased so that readers can learn from actual cases.

強さを引き出すブランディング

Pages: 144 (Full Color) ¥2,400 + Tax ISBN: 978-4-7562-4730-8

物が溢れ、似たような商品が山のように並ぶ店頭で、いかに選ばれるブランドになるか？というのは、多くの企業が抱える課題といえます。そのような問題を解決するために、商品の価値を一から見直し、ブランドストーリーをしっかりと組み立て、最後まで一環してクリエイティブな思考で作り上げる、ブランディングが注目されています。本書では、大企業の商品開発から、中規模のブランドやショップ、そして地域の小さな商品開発など、クリエイターたちが取り組むブランディングのプロセスを、制作者のコメントを交えながら紹介していきます。業界のあたりまえを覆し、アイデアひとつで新しいビジネスを生み出していく、ブランディングデザインの最前線です。

※ This title is available only in Japan.

Hot Local Designers Profiles
地域を熱くする！注目のデザイナーたち

Pages: 240 (Full Color) ¥5,800 + Tax ISBN: 978-4-7562-4367-6

今、地域に関わるデザインを、全国に向けて発信するデザイナーの存在感が増しています。そこで、本書では従来の年鑑本では見ることができなかった、北海道から沖縄まで、その地域で活躍する実力あるグラフィックデザイナー100名以上の仕事と連絡先を紹介します。

This book introduces around 120 designers who are active in local Japan. They create various local community-based items, such as package designs, pamphlets, advertisements, etc., for the branding of local products or for the promotion of regional tourism. The contents are classified into local areas of Japan and each designer's accomplished works as well as their contact information are included. This book will be a useful reference not only for people who are involved in local projects and seeking for new designers but also for designers who are looking for fresh inspiration.

Cheer Up! Hot Local Communities of Japan: By the Power of Graphic Design
デザインで地域を元気にする、プロジェクトと仕掛人たち

Pages: 144 (Full Color) ¥2,400 + Tax ISBN: 978-4-7562-4591-5

日本再生に向け、地方の伝統工芸や、第一次産業、そして過疎化した村を救うために動き出したデザイナーやクリエイターたち。ただデザインを提供するだけでなく、一緒に考え育てて行く、新しい取り組みが注目を集めています。本書では、デザインで新たな魅力を生み出す人、商品、そして活動の秘密にせまります。

Recently in Japan, there has been a movement for designers and creators to revitalize local communities with their fresh designs and innovative ideas. This book features people, products and activities in local that successfully renewed their appeal by the power of designs.

Local Packaging Now: Best Package Design of Local Products and Souvenirs
地域発 ヒット商品のデザイン

Pages: 384 (320 pages in Color) ¥3,800 + Tax ISBN: 978-4-7562-4449-9

消費者の心をつかむ、おみやげもの・特産物が大集合！日本全国、その土地のおみやげものや特産物は数多く存在します。たくさんの商品の中から、観光客をはじめとした消費者の手にとってもらえる商品は何が違うのか？！本書では、パッケージのデザイン・ネーミング・商品コンセプトなどクリエイティブの力で売上げを伸ばし、話題となっている全国のおみやげものや特産物を紹介します。

There are tons of souvenirs and special local products in each region throughout Japan. Recently their package designs are remarkably improving to be selected from those diverse choices. This book introduces highly-selected package designs of local souvenirs and products that have been a big hit. It will be a good reference for not only designers but also for people in tourism or local industries who are looking for new inspiration. Japanese only and mostly visual.

デザイナーのための著作権ガイド

Pages: 208 (128 in Color) ¥5,800 + Tax ISBN: 978-4-7562-4040-8

例えば Q. 竹久夢二のイラストを広告のビジュアルとして使ってもいいのか？ Q. 自分で撮影した六本木ヒルズの外観写真を雑誌広告として許可なく使えるのか？→答えはすべてYESです。※但し、個別のケースによっては、制限や注意事項があります。詳しくは本書籍をご覧ください。クリエイティブな仕事に携わる人が、知っておけば必ず役に立つ、知らなかったために損をする著作権をはじめとした法律や決まりごとがQ&Aですっきりわかります。

※ This title is available only in Japan.

カタログ・新刊のご案内について

総合カタログ、新刊案内をご希望の方は、下記パイ インターナショナルへご連絡下さい。

パイ インターナショナル
TEL: 03-3944-3981 FAX: 03-5395-4830
sales@pie.co.jp

CATALOGS and INFORMATION ON NEW PUBLICATIONS

If you would like to receive a free copy of our general catalog or details of our new publications, please contact PIE International Inc.

PIE International Inc.
FAX +81-3-5395-4830
sales@pie.co.jp